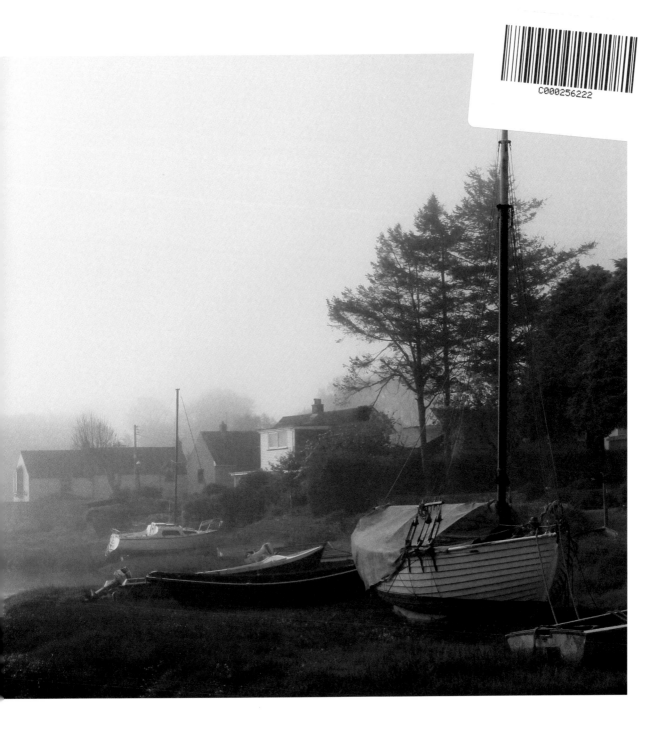

Cover: **Gareth Jones on the Cleddau Estuary with the village in the background.**

Previous page: **A morning mist at Guildford Pill on a rising tide.** Guildford Pill is one of two pills in Llangwm that flow into the Cleddau Estuary, the other being Edwards Pill. The Guildford side of the village is to the right of the water in this image.

The Village
Published by Bird Eye Books, an imprint of Graffeg Limited in 2021.

Photography and text by David Wilson copyright © 2021. Designed and produced by Graffeg Limited copyright © 2021.

Graffeg Limited, 15 Neptune Court, Vanguard Way, Cardiff, CF24 5PJ, Wales, UK.
Tel: 01554 824000
www.graffeg.com

A CIP Catalogue record for this book is available from the British Library.

The publisher gratefully acknowledges the financial support of this book by the Books Council of Wales. www.gwales.com.

ISBN 9781802580488

1 2 3 4 5 6 7 8 9

THE VILLAGE
DAVID WILSON

BIRD EYE BOOKS

THE VILLAGE

In Pembrokeshire, west Wales, there is a village called Llangwm.
I live there with my family and by our reckoning that makes us lucky.
Threading down a gentle hill, past the pub and the shop and a chapel
and the church, the village settles around the tidal inlet of Guildford
Pill, which flows into the Cleddau Estuary. A stone bridge crosses
the pill into Guildford, which, though now a part of Llangwm, was
once a separate hamlet to its village neighbour. Surrounded by native
woods and sloping fields, Llangwm stands apart; the road through
the village loops back to the main road from which it came, making
Llangwm *the* destination. In the past this isolation bred a fierce sense
of identity amongst the villagers. To be a *Llangwm* was, and still is, a
source of pride, and although I arrived by chance 20 years ago from
nearby Haverfordwest with my then girlfriend Anna, it was one of the
most fortuitous decisions we ever made.

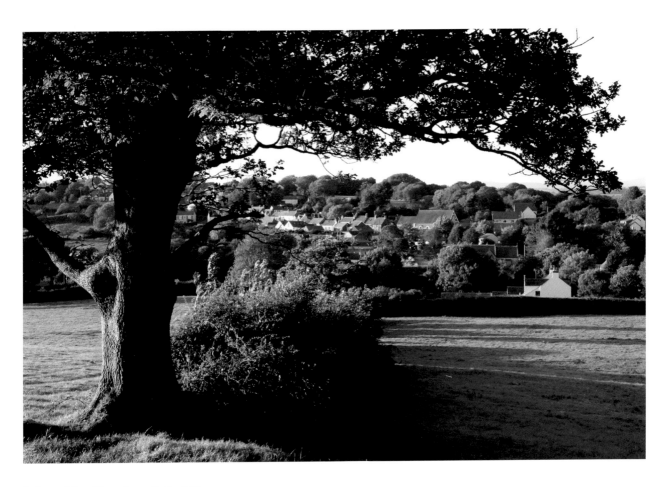

A view of the village from Butterhill,
surrounded by native woods and
sloping fields.

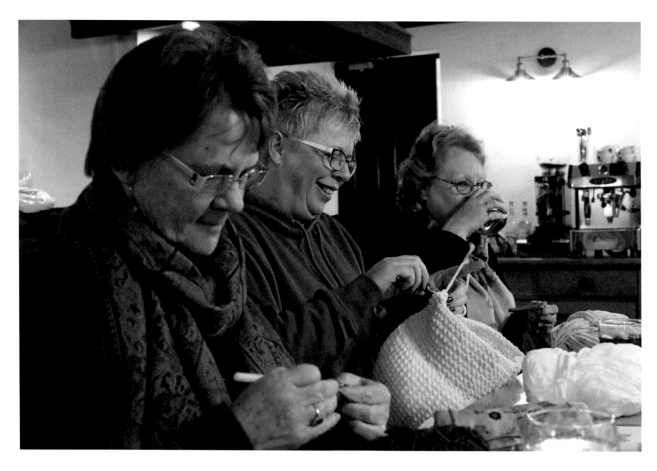

The 'Positively Loopy' crochet group.
'Positively Loopy' meet regularly in the Cottage Inn to crochet and teach their skills to others. A few of the members, including Rachel Price (centre), decided to 'spread a little happiness' by making crocheted gifts and tucking them in nooks and crannies around the village for others to find, such as daffodils on St David's Day, hearts at Valentine's and bunnies at Easter. Also in the photo are Jaqueline Joseph (left) and Lynn Smith (right).

Wherever you go in the world, the Amazon or Lapland or a mile up the road from Llangwm to Hook, the village thrives.

The word 'village' is derived from the old French *vilage*, meaning 'houses and other buildings in a group'. A place larger than a hamlet but tinier than a town, they hum and crackle with the energy of their smallness, the inhabitants secure in being amongst their own.

There are competing interpretations as to who it was that constituted the founding story of Llangwm. Were they Flemings, an abrasive war-like people from modern-day Belgium invited over by successive English kings to pacify unruly regional elements, Anglo-Normans, who were arguably just as bloodthirsty as the Flemings, or was there a pre-existing native Welsh presence? Llangwm, after all, means 'church in the valley' in Welsh. If there was an early medieval Welsh populace, then they were in for a shock; the newcomers were in no mood for a negotiated takeover and the Welsh were evicted to the north of the county. That divide between an anglicised south and Welsh-speaking north of Pembrokeshire still exists.

In 1811 the antiquarian Richard Fenton passed through Llangwm on his tour of Pembrokeshire, commenting ungenerously, 'This miserable village consists of several low, straggling houses interspersed with trees, amidst mountains of oyster shells...' Fishing was the main occupation and in the 19th century the Llangwm fisherwomen gained a reputation for their hardiness, walking miles to towns in the county laden with panniers of fish and oysters; the luckier ones had a donkey to carry the load. These indomitable women were sought out by photographers, adorning Edwardian postcards and with articles written about them in newspapers and periodicals. They wielded influence in village society too, considered as equals to the menfolk, with some men even adopting their wife's surname.

By 1900 the oyster beds were exhausted and fishing had become an unviable way of earning a living.

Certain family names predominated, and with a limited number of Christian names used there was inevitably some confusion; the solution was the adoption of nicknames such as Candles, Bucket, Buffalo and Pinchers.

There was tragedy too. A cholera outbreak in 1854 killed 62 people in Llangwm and Guildford, a terrifying rate of attrition for a population in the lower hundreds. A tradition of stoning strangers is said to date from this time, as a deterrent to people entering the village. In living memory the phrase 'Stone 'em Johnny' could still be heard, though thankfully the tradition has now died out and it is a welcoming place.

By 1900 the oyster beds were exhausted and fishing had become an unviable way of earning a living. The men increasingly worked away from the village, in particular at the Royal Navy dockyard six miles downstream at Pembroke Dock. Fishing may not have been the main source of income by this time, but most families would still have owned a boat, and the ready supply of wood from the dockyard – often falling off the back of the proverbial lorry – came in handy for the repair of old boats and the building of new ones.

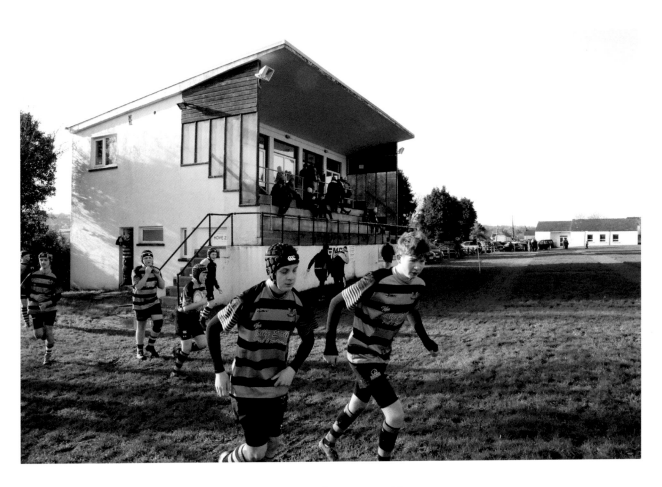

The U14s junior rugby team running out for a match against Fishguard at Pill Parks. Known as the Wasps – due to its hooped black and amber kit – Llangwm Rugby Club was established in 1885 and is one of only two village clubs in Pembrokeshire, the other being Crymych in the Preseli Hills. In the years following WWII the senior Llangwm team enjoyed great success, beating big town teams over a large geographic area to win West of Llanelli titles. Though such heights are now a distant memory, the club continues to thrive.

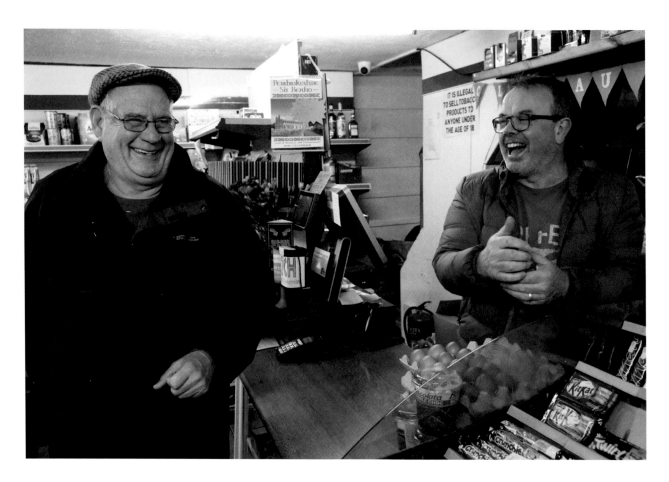

Dave Grayshon and Dave Golding, '...sharing a joke in the shop.' Formerly a blacksmiths, Cleddau Stores and Post Office is one of the main hubs of the village and is owned by Dave Golding. Dave's mum Julia was evacuated to Llangwm from London in 1940 during the Blitz at the age of five. She returned in 1968 with her husband, David Golding, who escorted convoys to Russia with the Royal Navy during WWII, and their five children, including eight-year-old Dave. The cottage where he grew up, in a field overlooking the estuary, is no longer there.

It is a story of community and of joint endeavour; that desire to feel a part of something bigger than ourselves.

In a world of increasing homogeneity – a dreary sameness – Llangwm retains a purposeful sense of individuality. And so, in January 2019, I set out to document a year-long snapshot in the life of this busy village with its church and chapels and rugby and cricket clubs and festivals and societies. In this little place of huge activity, I photographed people at home, at work and at play. Although the project was specific to Llangwm, the story it tells is a universal one. It is a story of community and of joint endeavour; that desire to feel a part of something bigger than ourselves. It is a story of hope, continuity and the unconquerable human spirit. It is the joy to be had from tiny pleasures: running out onto a rugby pitch with your teammates; sharing a joke in the shop; singing with friends; being out on the river with the early morning sun on your face. The novelist Leonardo D'Onofrio put it perfectly when he wrote in *Old Country*, 'Village life gently swirled around them, with the perpetual ebb and flow of people... The village was a living, organic entity, with blood flowing through its veins, and with a definite pulse and heartbeat.

It had its own distinct personality and its own dark caustic humour...' A thick skin can certainly come in handy when dealing with the Llangwm wit!

Within months of completing the project society was in the grip of a pandemic, with the emotional touchstones of daily life thrown into turmoil. What I had documented during 2019 was put into a state of suspension as our community struggled to come to terms with an altered reality. The situation, though, provided an opportunity to photograph an unexpected epilogue. The images of lockdown are far removed from the spirit of the main body of the book and as we re-emerge into a normalised existence I am reminded of what it is that separates us from other species on this planet – that bright contemplation of a better tomorrow.

NEW YEAR

The Cleddau Estuary cuts deep into the heart of Pembrokeshire and the invading Anglo-Normans and their Flemish allies used the waterway to great effect, establishing major castles at Pembroke, Carew and Haverfordwest in addition to many minor strongholds, which they used to subdue the native Welsh population.

Guildford Pill at low tide looking towards the Cleddau Estuary in the distance. The shoreline around the village is dotted with old boats, some of which are submerged by the incoming tide. In the generations that have passed since Llangwm's fishing heyday the pill has silted up, forming raised banks of spartina grass on either side. Old photographs, by contrast, show shingly beaches with the distinctive Llangwm fishing boats tied up on the shore. On this frosty January morning I was drawn to the intricate pattern of ice crystals and the knotted rope on the bow.

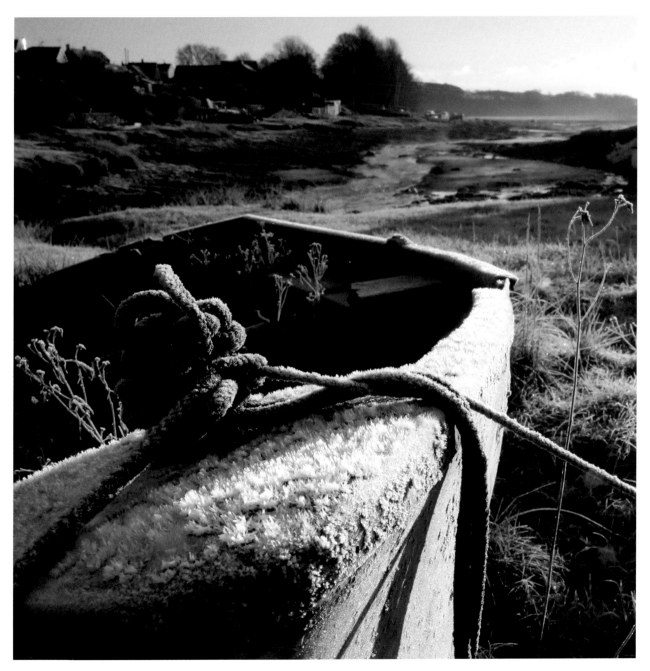

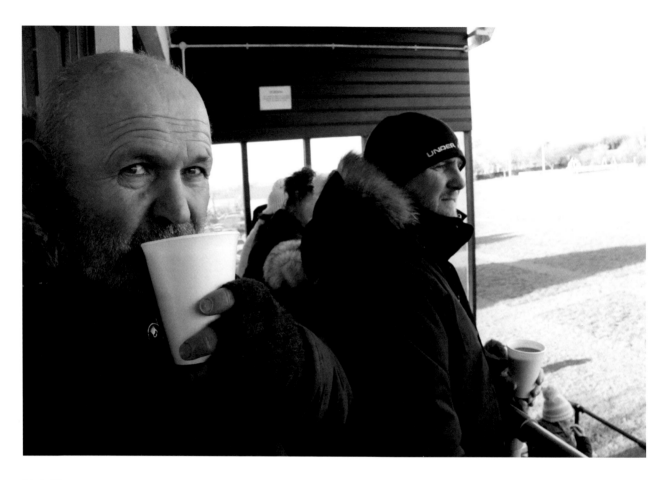

Chris Thomas and Gary Phillips watching their sons playing for the U14s rugby team against Fishguard at Pill Parks on a bitterly cold day.
Before the stand was built it wasn't unknown for the home supporters – whose encouragement of the Wasps could be very determined – to encroach onto the playing area and physically impede an opposing team. On one occasion a mother took exception to the way her son had been tackled and stormed onto the pitch to sort out the visiting player. Some matches were subsequently rescheduled.

Page 13: **The Llangwm players (closest to the camera) compete at a line-out.**

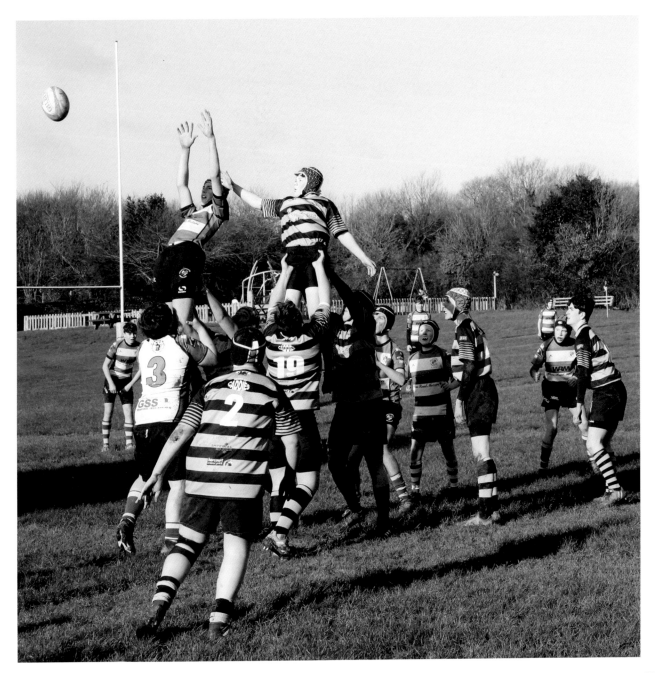

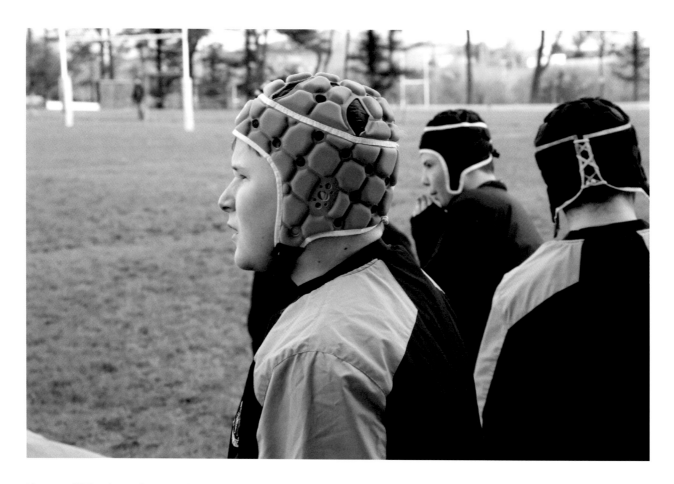

Llangwm U14 subs on the touchline at Pill Parks, awaiting their turn to play.
Pill Parks is host to a full sporting year, split between the rugby and cricket seasons. The players in the mini and junior rugby teams come not just from Llangwm but also the outlying villages and towns. Unfortunately, age groups in some mini and junior sections of rugby clubs around Pembrokeshire have folded due to a lack of numbers.

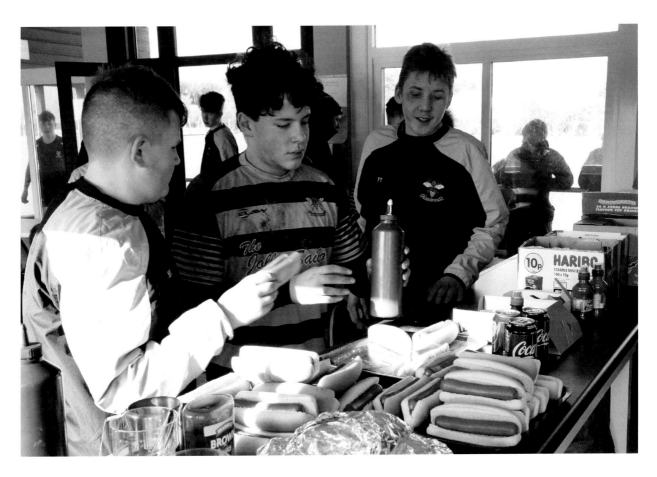

Hot dogs in the stand after the match help to ease the pain of losing.
Volunteers serve hot drinks and bacon rolls during matches to raise funds for the club and as games draw to a close they are busy in the stand's tiny kitchen warming up hot dogs ready for when the teams come in. As the players and parents depart, the volunteers clear up, wash up and mop up.

Pages 16-17: **Sunrise looking across the Cleddau Estuary towards Coedcanlas on the opposite bank.** The tide was out, exposing the mud flats and the navigable channel into Guildford Pill. The Cleddau Estuary cuts deep into the heart of Pembrokeshire and the invading Anglo-Normans and their Flemish allies used the waterway to great effect, establishing major castles at Pembroke,

Carew and Haverfordwest in addition to many minor strongholds, which they used to subdue the native Welsh population.

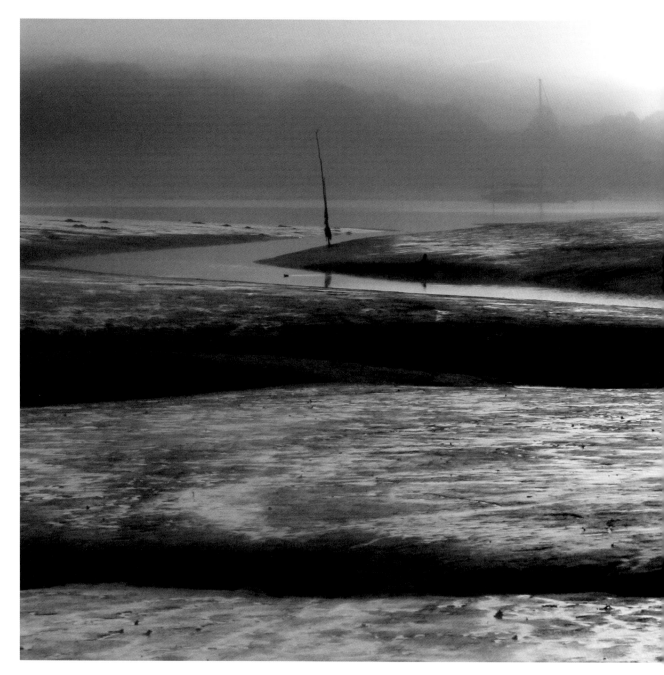

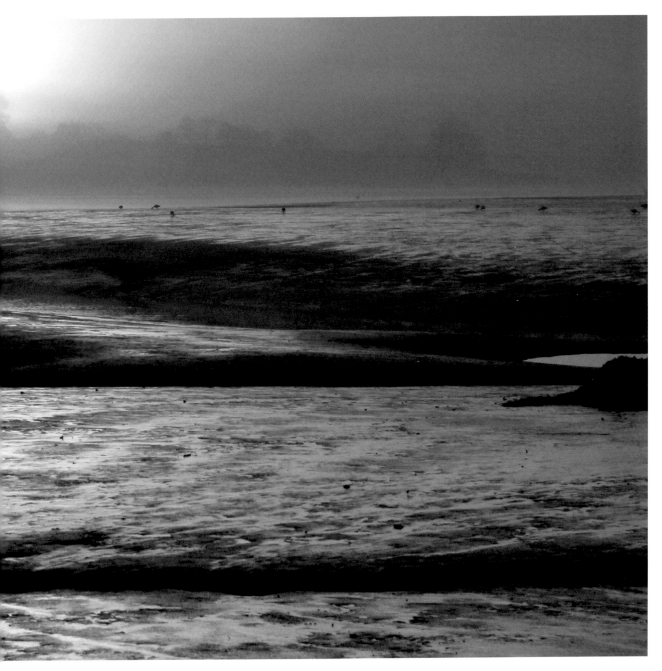

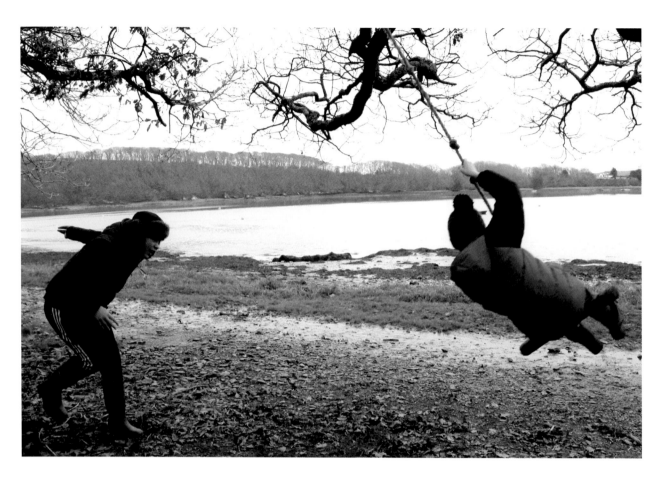

Rope swing at the Cunnigar, on the banks of the Cleddau Estuary. Cunnigar is a mutation of *Coney Gar*, meaning 'place of rabbits'. At one time, during the herring season, you could spot boats low in the water making their way slowly past the Cunnigar back to Black Tar after a good catch. In more recent times, the fish were sold to the herring man, who called in his van.

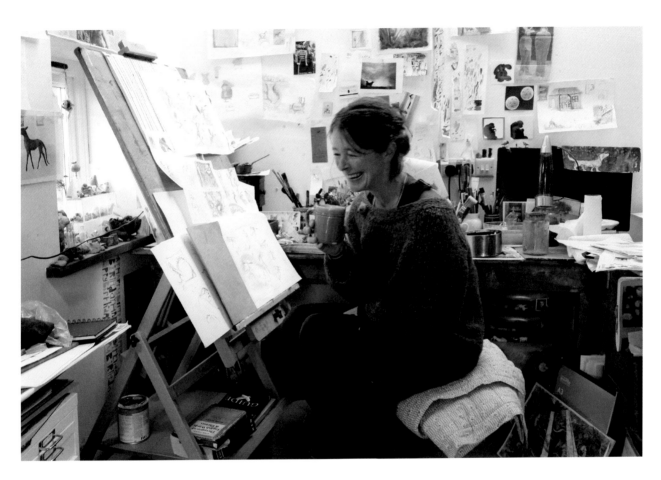

Artist Fran Evans in her garden studio.
The author of several books, Fran's artistic inspiration comes from nature. Lifting a mossy stone or peering behind the bark of a tree, Fran spies a private world of beetles and snails and a whole cast of tiny characters that inform her storytelling. She arrived in Llangwm by happy chance 20 years ago; lots of us have arrived in similar fashion. When she was younger, an interest in the environment led her to work on a humpback whale research expedition, sailing off the coast of Australia on a wooden tall ship. 'I was basically a galley slave and general dogsbody but it was one of the best jobs I've ever had.' She also bumped around Botswana with a group of fellow students in the back of a cattle truck while conducting research for a book.

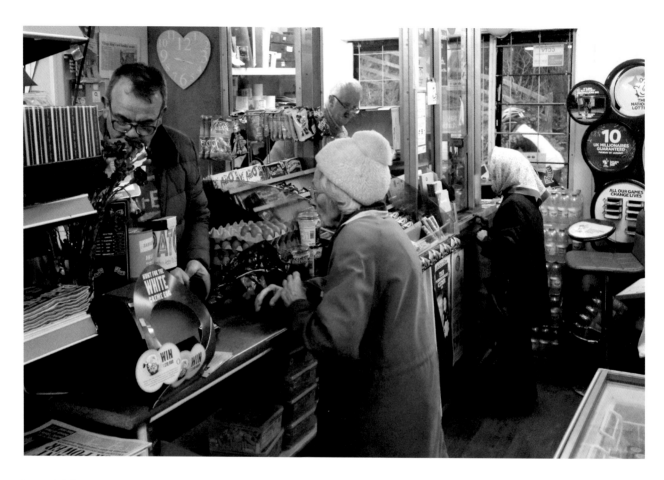

Dave Golding and Martyn Davies serving customers, Cleddau Stores and Post Office. There's always been a shop – or in previous years, shops – somewhere in the village. Older residents will recall Johnny Palmer's shop in Cleddau House, just off Rectory Road. As well as blocks of Lyons Maid ice cream and freshly sliced ham, there was a drapery section, a display of toys in the run-up to Christmas and, of course, fireworks for Guy Fawkes night; it seemed you could buy anything and everything. There were butchers and bakeries in the village too, the smell of freshly baked bread in the street still fondly remembered. Local children, not to be outdone, had a choice of sweet shops, including Gus Brown's, near the stepping stones at Guildford, and Alberta's on the Green.

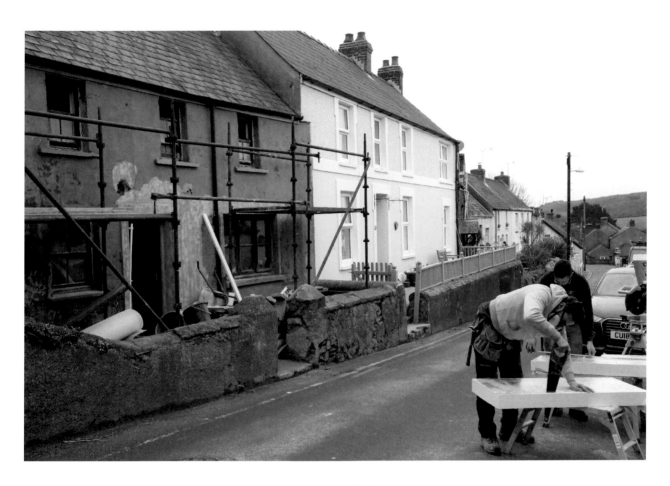

Renovating Elm Cottage in Main Street.
The tiny cottage was built by Mary Palmer and her husband John in the mid-19th century; she helped dig the foundations, mix mortar and transport stones to the site. Mary was a fisherwoman whose treks to market carrying as much as a hundred weight of oysters were legendary. Giving birth to nine children was no mean feat either.

She wasn't averse to a bit of controversy. During the Llangwm riot of 1900 – when a crowd in their hundreds gathered outside the house of Mary's neighbour to protest against an eviction – she allegedly joined in with not only stoning the property but also the policemen summoned to restore order.

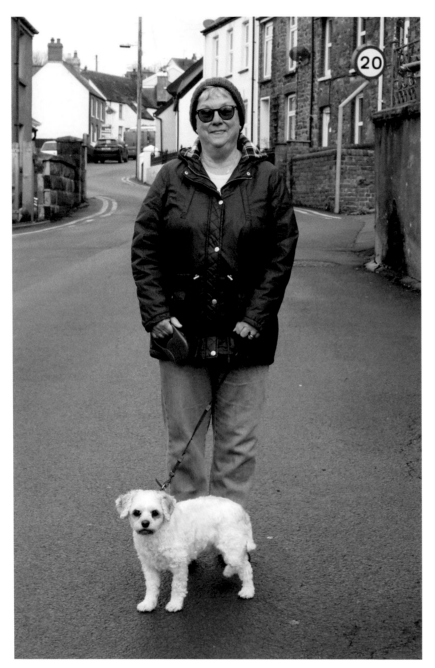

Avril Platten and Poppy at the bottom of Main Street. Avril was brought up in Glan Hafan with her brother and sister, where 'everyone knew everyone, and all the children played together'. But, she said, the boys were always treated like little princes. 'They had the rugby and the cricket, there was plenty for them to do, but there was nothing for the girls to do, nothing. It's altered a lot now.' Unlike the welcome of today, in the past Llangwm was not an easy place to be assimilated. Avril's mother, Mrs Ruth England, arrived in the 1940s from Scotland, having married Avril's father, Idwal England, from the village. Idwal had met Ruth in Aberdeen while in the Royal Marines during WWII. On first meeting her husband's auntie in Llangwm, Ruth was asked pointedly, 'Canst thou use a sweeping brush?' She replied that she could and was asked to prove it there and then! 'Llangwm was such a close community. At first my mother found it hard. Really, really, hard.'

'Wrong Direction' musical director Neil Martin (right) and tenor Graham Brace arriving for singing practice at St Jerome's Church. Llangwm's very own boy band was formed in 2017; the three-part male vocal ensemble meets on Tuesday mornings.

**Conversation and laughter over a
cuppa are the usual prelude to practice.**
'Wrong Direction' continues a long
tradition of singing in the village. The
Rev. J. Arthur Turner wrote in 1900 that
'The singing of the Llangwm people is
famous for its heartiness and strength.'

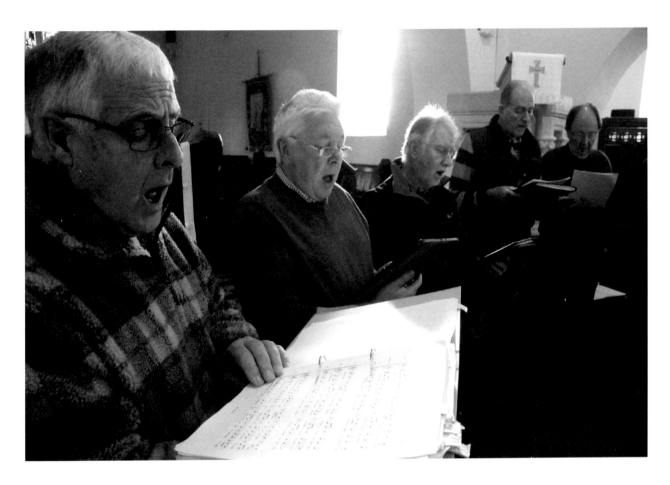

With a forthcoming performance at the annual medieval festival at Malbork Castle in Poland, the group get down to some practice... eventually.

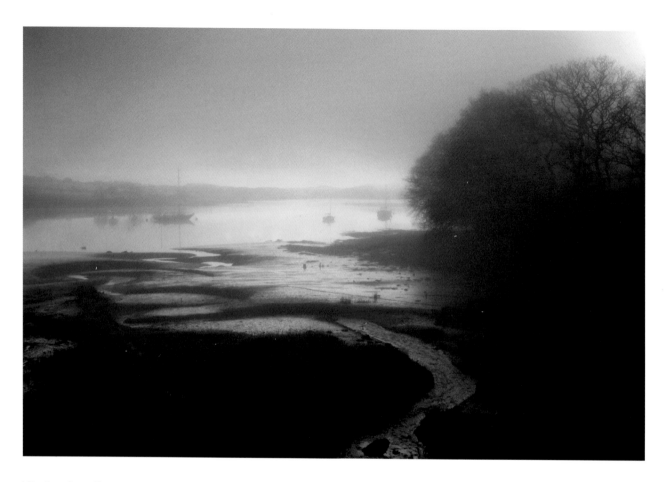

Mist burning off as the sun rises at Port Lion. Years ago, it was often more convenient to leave the village by boat, as there was a ferry across the estuary from Port Lion to Coedcanlas on the other side of the water. The ferryman, or waterman, lived at the edge of Benton wood, to the right of the picture, in a cottage near the shore. Just a few walls now remain amongst the trees.

Six miles downstream from here the wooded banks of the Cleddau Estuary give way to the town of Pembroke Dock, which until the 1920s was a Royal Navy dockyard and provided employment for many from the village. Past the town, oil refineries and gas storage facilities sit either side of an industrialised waterway down to Milford Haven and beyond. Admiral Nelson visited Milford

in 1802 – the Lord Nelson hotel was named in his honour – and he declared the Milford Haven waterway to be one of the finest natural deep-water harbours in the world. Eventually, 15 miles after leaving Llangwm by water, passing oil and gas tankers moored to jetties, you exit the haven at The Heads and are into the Irish Sea.

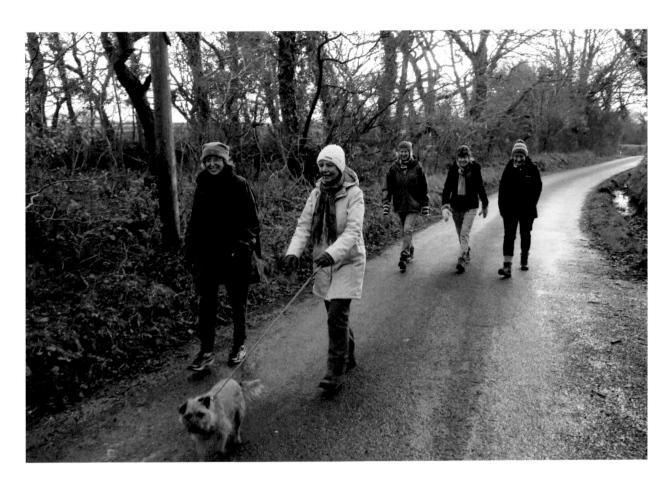

Early morning walkers heading up
Knapp Lane from Black Tar.

Galilee Baptist Chapel, Guildford.
The chapel was built in 1904, replacing a previous chapel nearby, which was knocked down, becoming a parking space for cars belonging to members of the congregation; it accommodates about six vehicles, which gives an indication of how small the original chapel was.

Dilwyn George delivering logs in Williamston Terrace, Guildford.

When he's not delivering logs in his pick-up truck, Dilwyn can often be seen driving a big blue van with Jed, his lurcher, by his side. He is a skilled craftsman, as evidenced by the hand-built kitchens and other beautifully worked features in local houses and further afield. His father, Douglas, a shipwright, taught Dilwyn how to work with wood, and Douglas had learnt from his father, Clifford, also a shipwright. In Dilwyn's own words he has always sought adventure, and in his younger days he worked as a miner at the Cynheidre colliery, near Llanelli, and was a deep-sea fisherman, catching hake 200 miles SW of Ireland and in the Bay of Biscay.

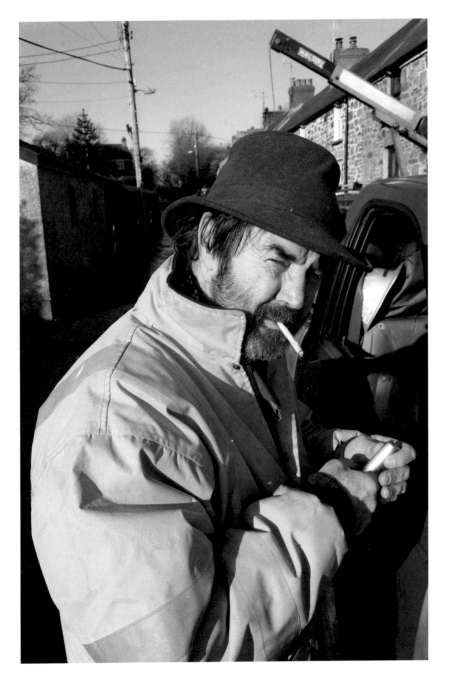

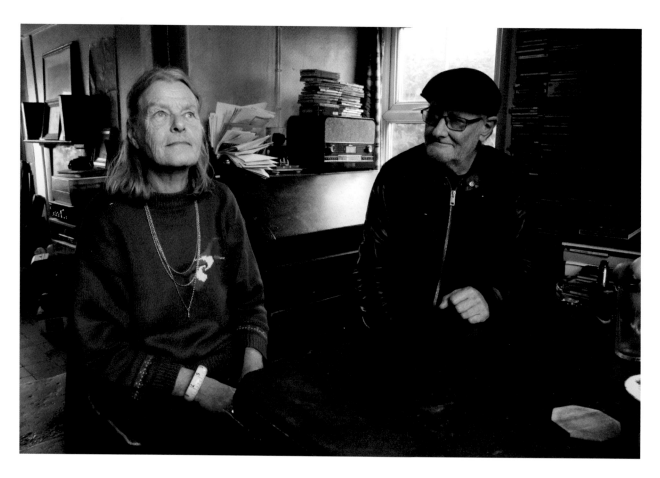

Bob and Sheila Jackson at home in Wellhead Lane. Bob had just returned from the shop with the day's essentials, which always include two bottles of Newcastle Brown Ale. Sheila is a painter and Bob a retired art lecturer. He is also an accomplished musician, and as a young man at art college in Newport he taught Joe Strummer – a founder member of The Clash – to play guitar; they played together in a band called The Vultures. Bob also played in another band at my wedding 16 years ago, which, with his Clash connections, makes me feel quite honoured.

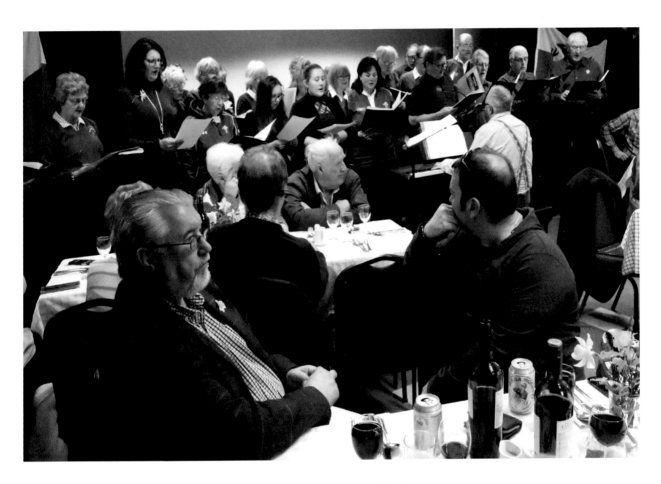

Llangwm Village Voices singing at the St David's Day supper in the village hall. It's not unusual for a village to have a choir, but it's definitely unusual for a village choir to stage a nationally acclaimed opera. In 2014, Llangwm Village Voices performed *WWI – A Village Opera* to mark the centenary of the war. Much of the story was set in the local community but it also included scenes from the battlefields of the Western Front. Composed by the choir's musical director, Sam Howley, and written by Peter George, the opera won an award in the *Daily Telegraph* Remember WWI competition.

SPRING

Some of the congregation remember the poet Waldo Williams cycling the six miles from his home on the outskirts of Haverfordwest on a Sunday evening in the 1960s to sit quietly at the back of the chapel to listen to the sermon.

Page 33: **A spring morning at Port Lion.** An hour after sunrise and the contrast between the shadowy details of the trees and rocks and the bright, glaring water is invigorating. As I took in the scene I heard the raucous bellow of a flock of Canada geese overhead that have made this stretch of the Cleddau Estuary their home, having supposedly been introduced by a local gentry estate in the late 19th century. The solitude, the smell of the mud flats and seaweed washed up on the high-tideline and the sight of the geese provided the perfect start to the day.

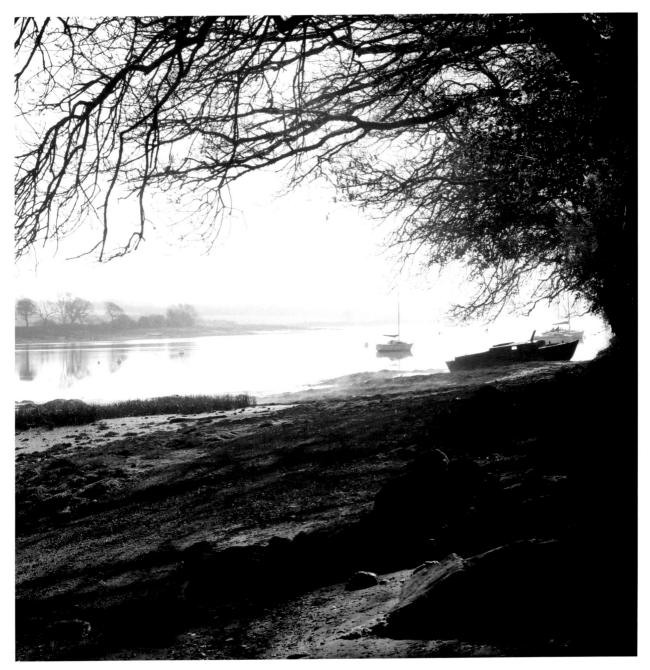

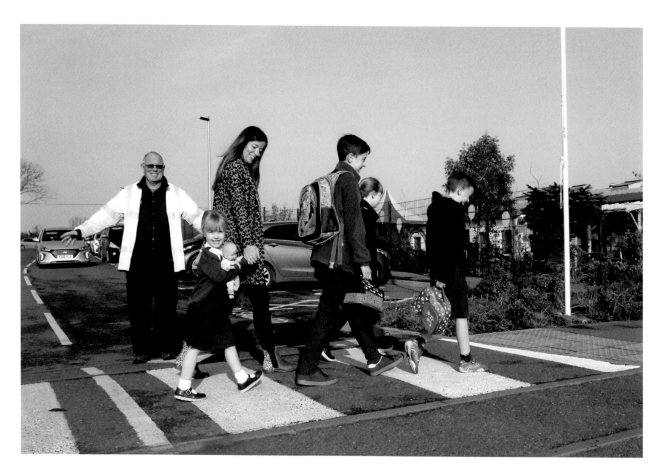

Start of the day at Cleddau Reach VC School. School caretaker and ex-police officer Steve Richards supervises the crossing as Tasmin Nash arrives with her four children at the village primary school. Like many before her Tasmin left the village to attend university, going on to gain a Masters in Theatre Design at the prestigious Slade School of Fine Art in London. She subsequently worked as a costume design assistant on *Jerry Springer: The Opera* at the National Theatre as well as designing sets and costumes for a number of shows at the Edinburgh Fringe Festival. Llangwm, though, was full of happy memories and so she returned to the village with her future husband Richard to renovate a stone cottage and raise a family, as '...we wanted our children to have the beautiful and safe upbringing that I had.'

Jane Brock at Cleddau Reach School.
Jane has been a cheerful and efficient secretary at the village school for 25 years, initially at the old Llangwm VC School at the Gail and then at Cleddau Reach, which was built on the periphery of the village in 2013 to replace it. When the school day is over, she goes home to work on the family farm.

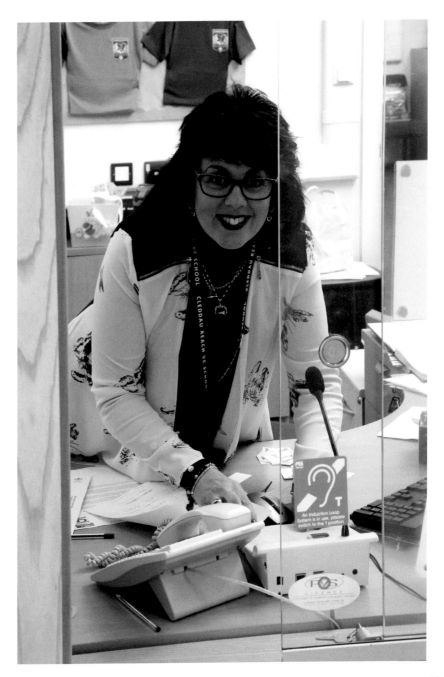

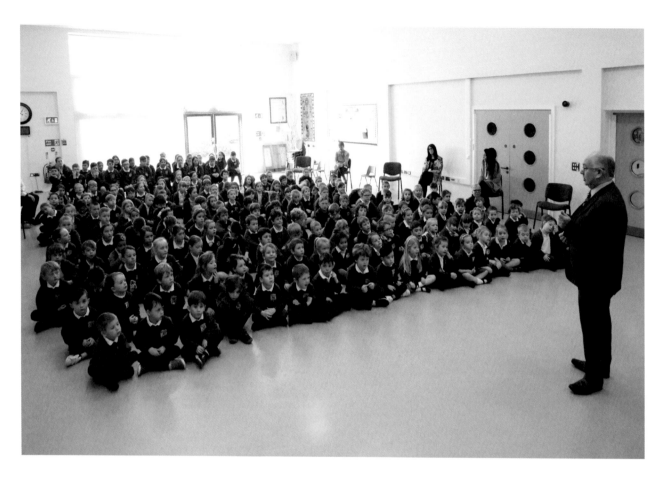

Head-teacher Nick Groves taking morning assembly. Some 240 pupils between the ages of three and eleven attend Cleddau Reach, far exceeding the number that attended the old Llangwm School, which was merged with the nearby Burton VC School to form the new establishment. There was a period around 1970 when Llangwm School was threatened with closure as pupil numbers had fallen to below 30, but a timely increase in the population of the village saved it; rural school closures are not necessarily a recent blight.

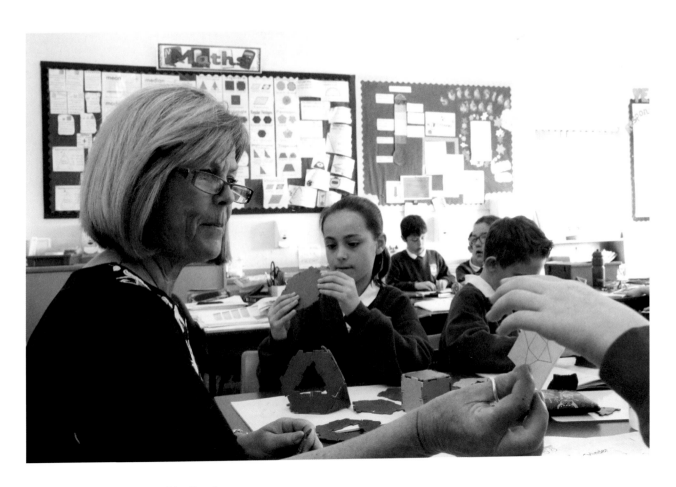

Learning Support Assistant Lisa Brock helping Year 5 pupils.

Pages 38-39: **With rugby, cricket and football clubs in the village, break-times at Cleddau Reach can be competitive.** Times have certainly changed, as many years ago at Llangwm School boys and girls were separated in the playground by a substantial wall.

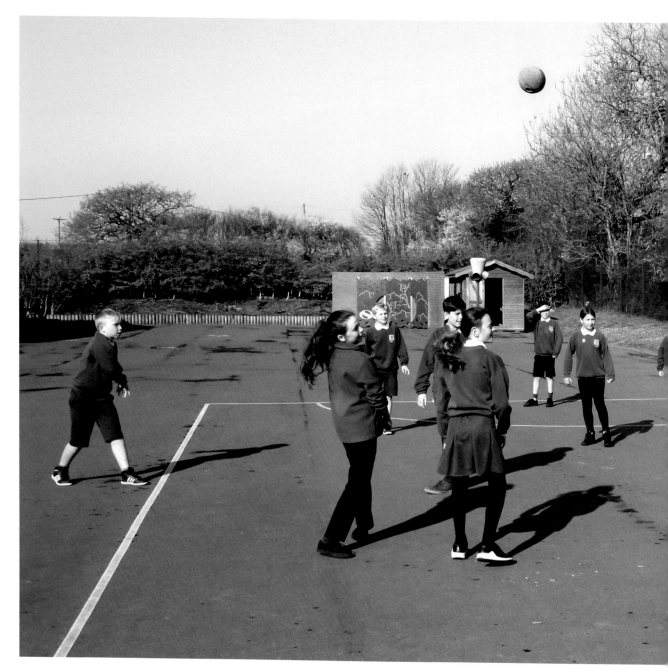

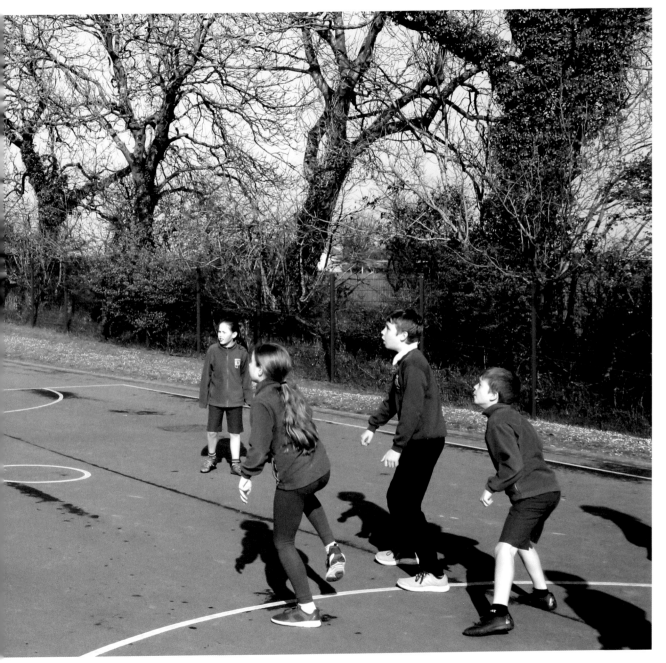

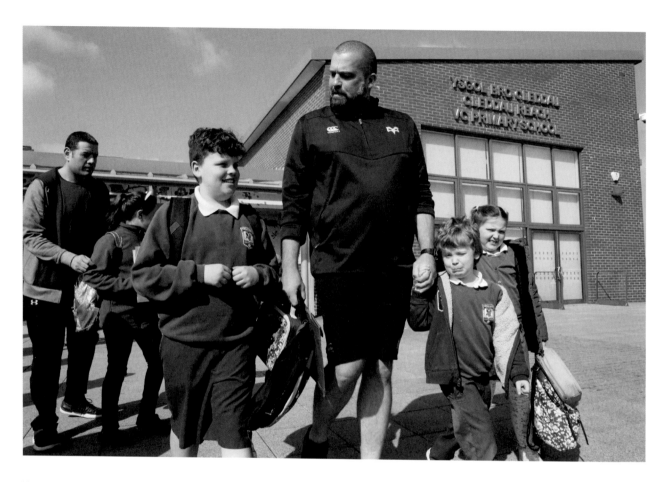

Hamish Nicholls collecting his boys at
the end of the school day to walk home.

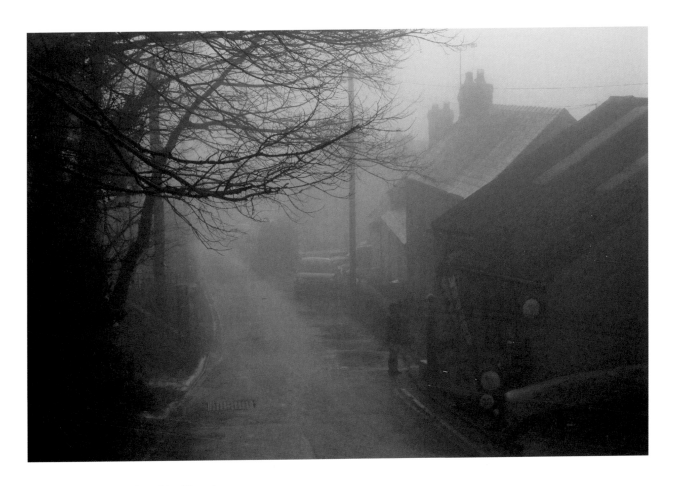

Main Street. Being a riverside village in a sheltered valley, morning mists are common.

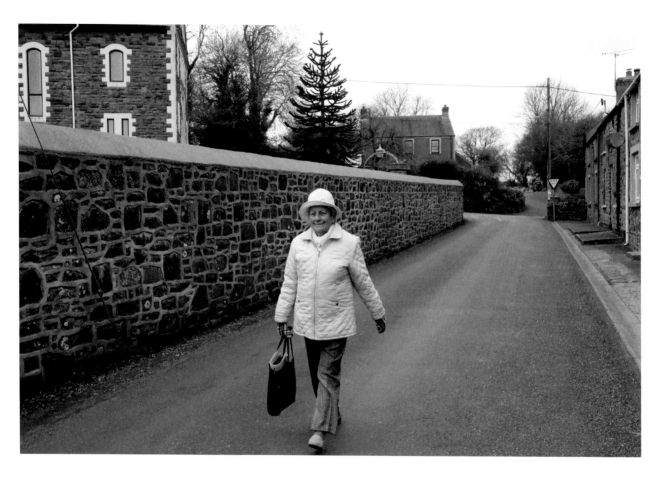

Gloria Woodward walking home from the shop along Williamston Terrace. The terrace was built in the late 19th century by the Lawrenny Estate, then landlords of most of the properties in the village. Legend has it that the terrace was used as a wager in the 1905 Grand National, and, on losing, ownership passed to another local estate. Opposite the terrace is Galilee Baptist Chapel.

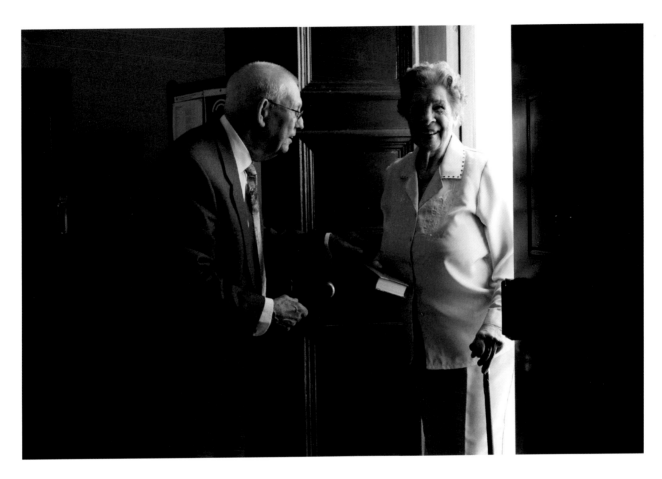

Gwyn Devonald greeting Avril Morgan on Easter Sunday at Galilee Baptist Chapel. A gentle and courteous man, Gwyn was a retired bus driver who is remembered with great affection by many of the children from the village who he transported to Sir Thomas Picton and Tasker Milward secondary schools in Haverfordwest. Sadly, since the photograph was taken, Gwyn has passed away.

The congregation of Galilee having a catch-up before the service begins.
Some of the congregation remember the poet Waldo Williams cycling the six miles from his home on the outskirts of Haverfordwest on a Sunday evening in the 1960s to sit quietly at the back of the chapel to listen to the sermon. An avowed pacifist, he served two jail terms for his refusal to pay income tax in a protest against war and compulsory military service and is considered by many to have been the greatest poet in the Welsh language of the 20th century.

Tony Cole, Galilee Baptist Chapel.
Born in a cottage in Main Street, Tony
moved into sheltered accommodation
in Haverfordwest five years ago, having
lived his whole life in Llangwm. He still
drives to the village every day, to chapel
on Sundays and to deliver the paper
to an elderly lady who was once his
neighbour.

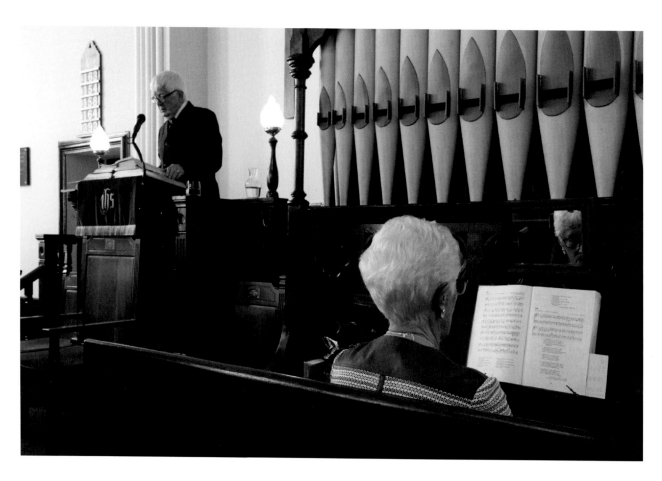

Organist Margaret Davies accompanying
the singing as Minister Roger Hart
prepares to deliver his sermon.

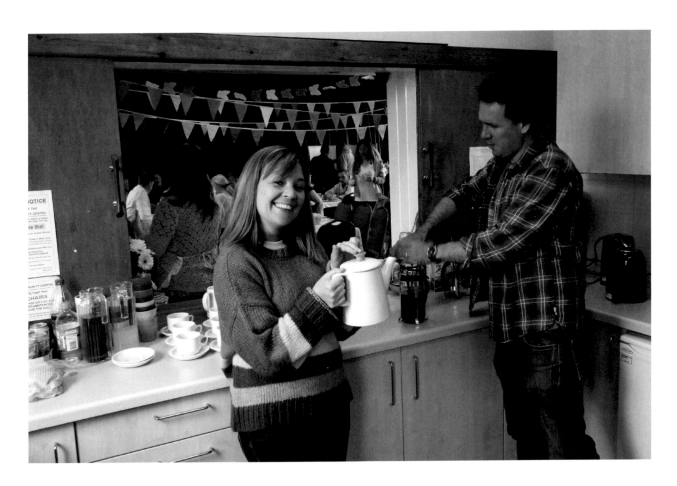

Helen Luff and Phil Wensley helping out in the kitchen at a pop-up café in the village hall. A number of cafés have been held in recent years to raise money for various charities and are always very well attended.

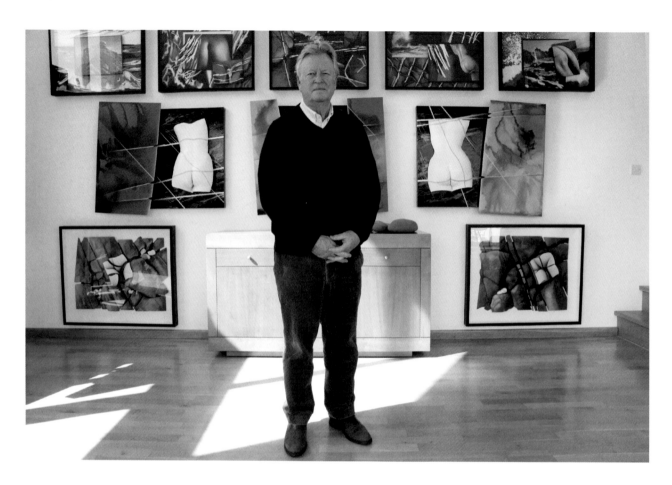

Artist Ian Jacob in his studio at Black Tar. Ian was born in Llangwm and left the village in 1968 to study at art school. After graduating he enjoyed a successful marketing career in London before promotion took him to New York during the mid-eighties. Aware of his hunger for news from home his mum posted the *West Wales Guardian* newspaper to Ian every week for the five years that he, his wife Christine and their children lived in the state of Connecticut, 30 miles from his office in the city. Prior to his mum flying out to visit them – the only time she ever flew – there were some 'home comfort' requests from the family: Hula Hoops and Hartley's fruit-flavoured jelly for the children, Rowntree's Fruit Pastilles for Christine, and Leo Dried Peas for Ian. She landed in JFK Airport with a bulging suitcase held together with a thick leather belt that she somehow got through customs. Ian returned to live in Llangwm with Christine in 2008, when he was able to commit full-time to his art.

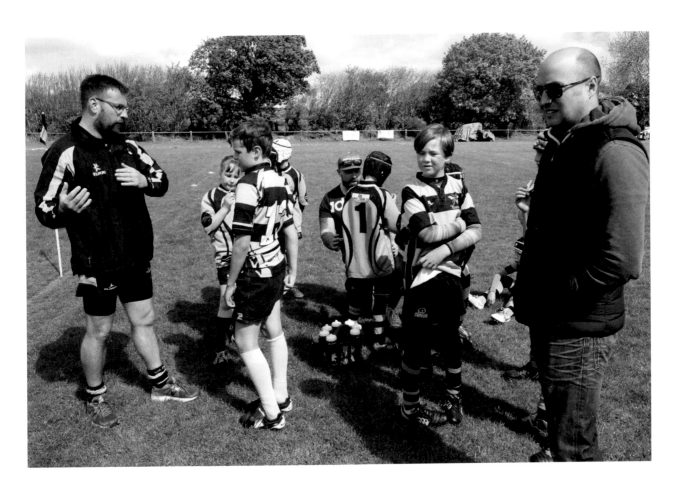

U10s rugby coach Simon Preddy (left)
preparing the Llangwm team for
an end-of-season friendly against
a touring side from Llandaff RFC in
Cardiff.

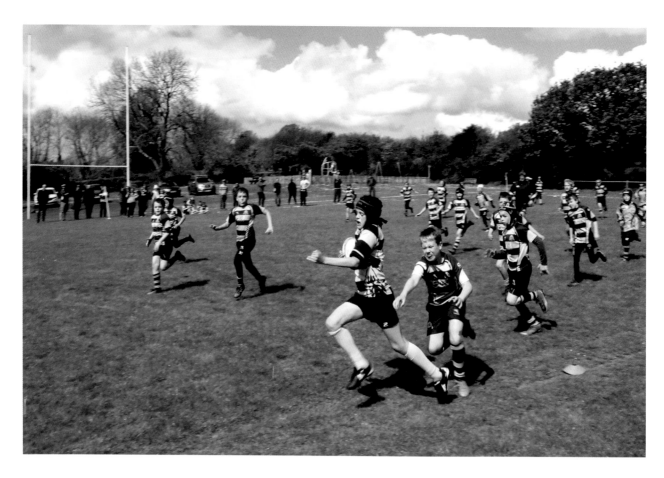

Playing on a shortened pitch between the touchlines, a Llangwm player evades a host of tacklers before going on to score. Pill Parks was compulsorily purchased from a local farmer in the 1950s (it was reputedly an acrimonious episode) to provide the village with a rugby and cricket pitch. Prior to that rugby had been played on Butterhill Meadow and there was a song, part of which went, 'The boys come out to play, Away to Butterhill meadow we'd go most every Saturday.'

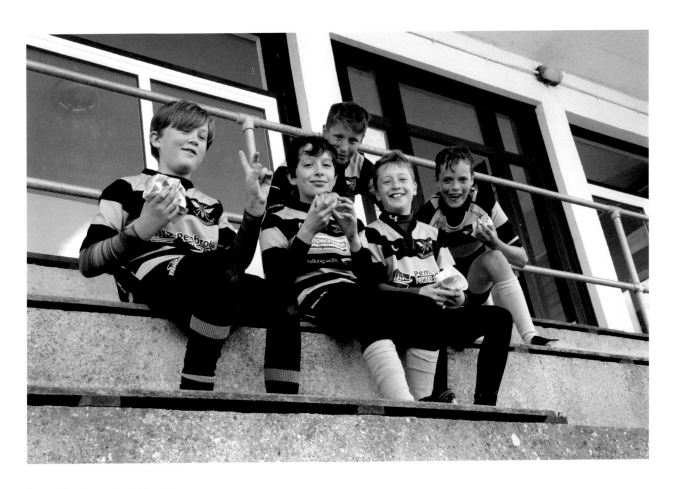

Embracing the social side of the game.

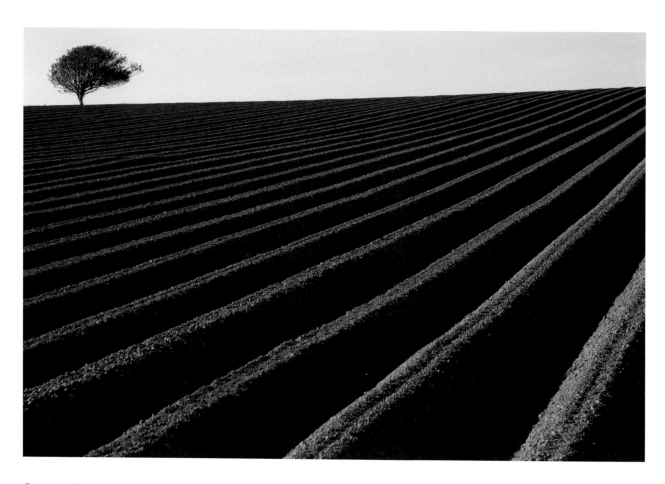

Potato drills at North Nash Farm.

**Stephen James Skyrme Lewis –
Skyrme to all who know him (and
a lot do) – of North Nash Farm.** A
'larger-than-life character' is perhaps
an overused cliché, but in Skyrme's
case it happens to be true, and it's
a trait that appears to have run in
the family. His grandfather, Jimmy
Lewis, fought throughout WWI, seeing
action at the Battle of the Somme and
being awarded the Military Cross for
gallantry. After the war he acquired
North Nash Farm, a quarter of a mile
outside the village. In WWII Jimmy
volunteered for the Auxiliary Units,
covert operatives trained in the use
of explosives and weapons, who in
the event of a German invasion would
melt into the landscape to launch
hit-and-run attacks on the enemy.
During the war, with food distribution
strictly rationed by the Ministry of Food,
Jimmy and his mate Selwyn Morgan of
Llangwm Farm – situated in the village
– slaughtered and butchered livestock
on the side at North Nash.

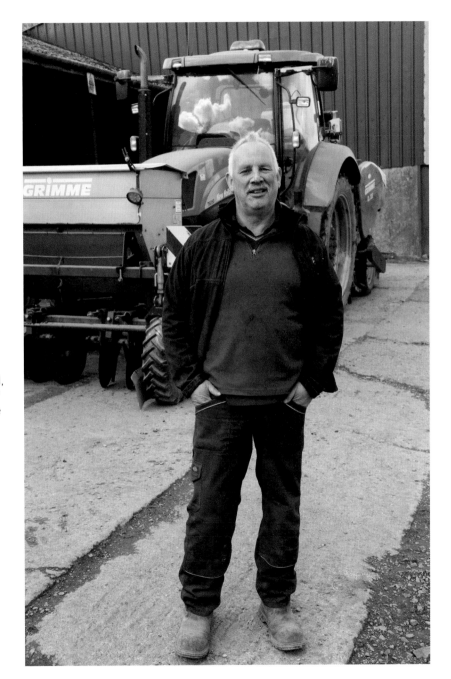

SUMMER

During the festival fortnight in July the village comes alive with scarecrows of varying sizes and levels of mechanical complexity.

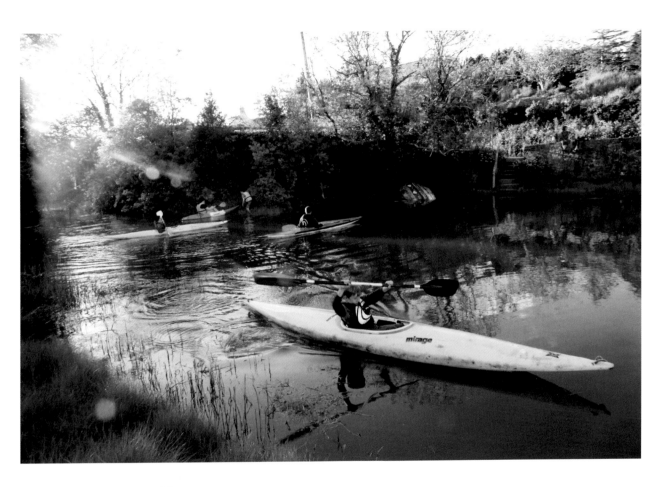

Boys canoeing in Guildford Pill at
high tide.

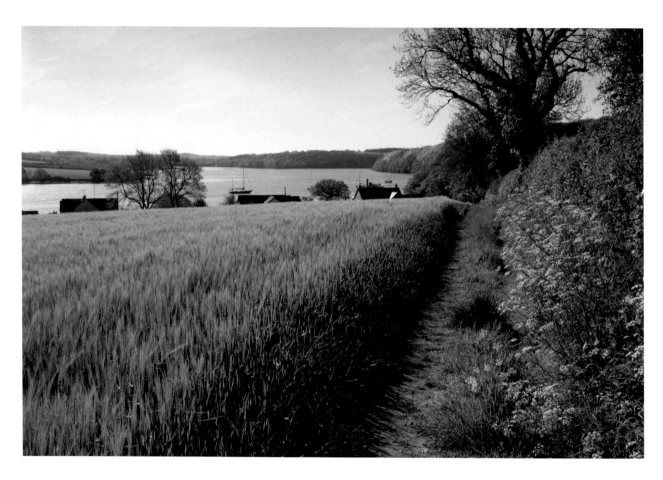

Looking towards Llangwm Ferry and
the Cleddau Estuary.

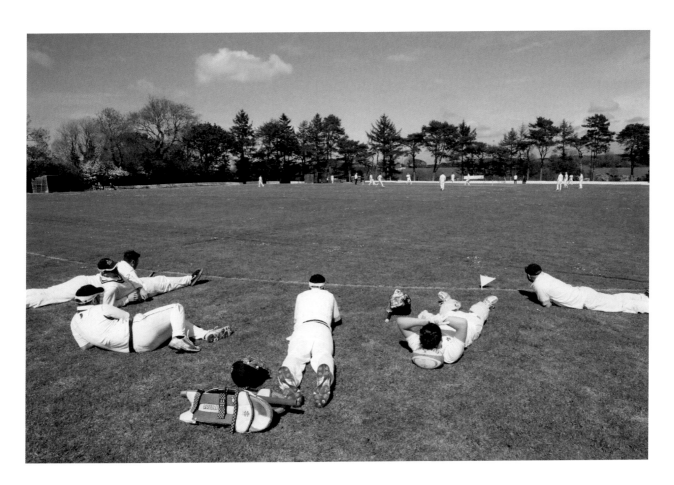

A cricket match at Pill Parks. Following afternoon tea, the Llangwm players await their turn to bat. Playing in the Pembroke County Cricket League, the first team were at home while the seconds were playing away. Pill Parks is not big enough to accommodate separate rugby and cricket pitches and so ground preparations for the cricket season include the removal of a set of rugby posts from the outfield. From late spring and throughout the summer months Pill Parks and the stand become the domain of the cricket club before reverting to the rugby club in September. These twice-yearly transfers of overlapping territory are usually achieved without incident!

Pat Morris at home in Lake Villas.
A well-known local figure, Pat used to run the shop until ill-health forced her to retire, after which her brother Dave Golding took it over. One of the many doers in the village, Pat was a long-serving member of the community council and the festival committee.

Pembrokeshire county councillor Michael John chairing a meeting of Llangwm Community Council in the village hall. Once the more pressing items on the agenda had been considered, the eight councillors, aided by a clerk, discussed a range of less glamorous issues, such as the prevention of dog fouling on the playing fields at Pill Parks and a volunteer rota for cleaning the public conveniences at Black Tar, a responsibility inherited from the county council. Previous chairman Barry Childs recalls that when he joined the council in his twenties it was the Llangwm and Hook Parish Council, but some years later Hook decided they wanted to separate 'on the not unreasonable grounds that the council seemed to spend most its time discussing matters to do with Llangwm, though we met alternately in the two village schools'.

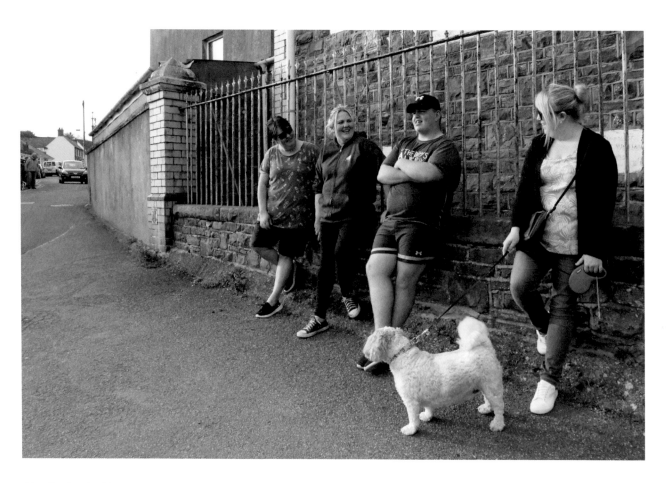

Chatting by the Methodist Chapel on
the Green.

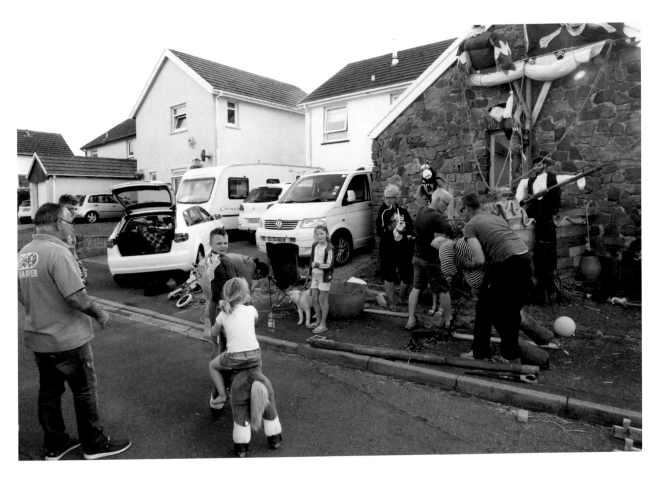

The residents of Gail Rise making their entry for the annual scarecrow competition. During the festival fortnight in July the village comes alive with scarecrows of varying sizes and levels of mechanical complexity. Launched as a fundraiser for the millennium celebrations, the competition was so popular it became an annual event, attracting sightseers from miles around. The theme this year was 'pirates'.

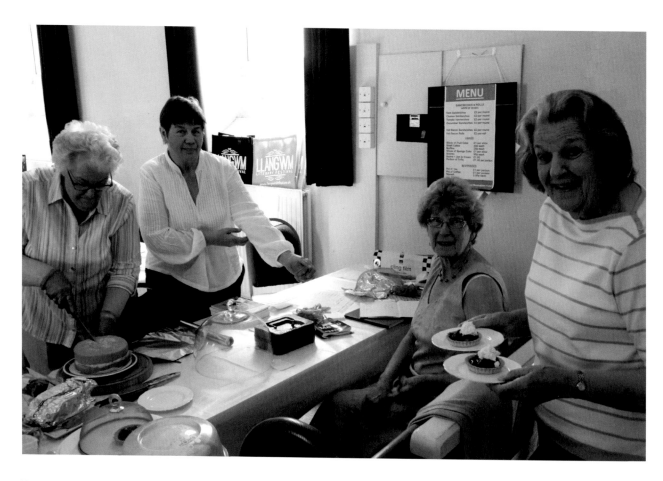

Teas in the Wesleyan Methodist Chapel school room during Llangwm Festival Fortnight. Elizabeth Davies (second left) is ordering a slice of Victoria sponge from chapel members, who raise funds for the chapel by serving delicious food and drink throughout the annual festival. I popped in a few times to take photographs, though perhaps my returns were motivated more by the prospect of another slice of cake and a coffee. The bacon rolls were good too.

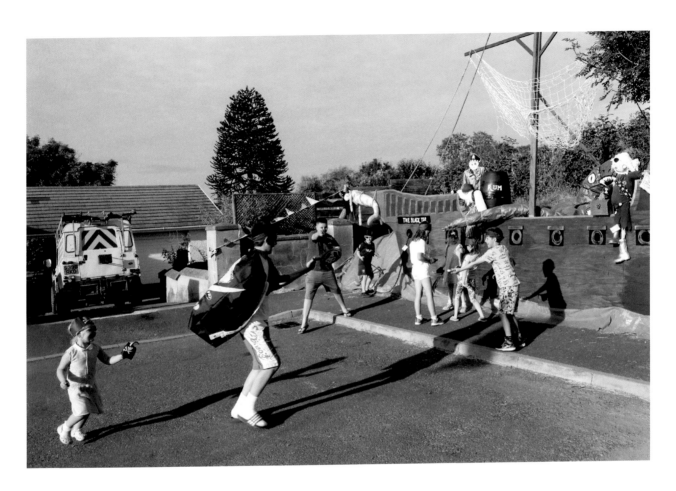

Children from River View playing pirates next to the estate's splendid entry in the scarecrow competition. The housing developments of River View and Gail Rise were built some 50 years ago on the periphery of Llangwm, helping to swell the population of the village and correspondingly the numbers of pupils at the village school.

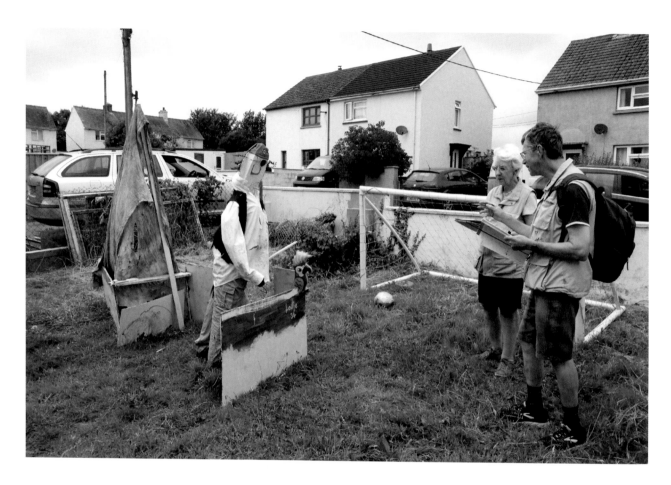

Judging the scarecrow competition.
Berndt and Maria Urban judge one
of the entries at Glan Hafan before
continuing around the village to view
the other scarecrows.

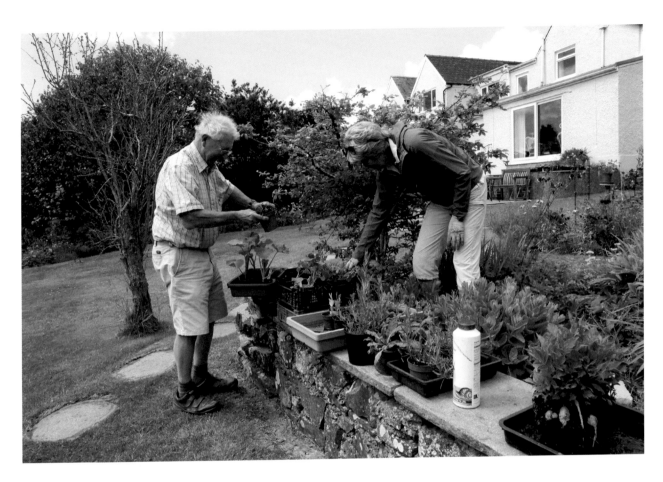

Stuart and Liz Beresford in their garden. When they retired, Stuart and Liz decided to grow plants and sell them from a stall at the front of their house. They were so popular that the couple made the decision to donate all the income to charity. Liz said that 'none of this would have been possible without the tremendous support given by our community'.

In the years they have been doing it, many local organisations have benefitted enormously from their efforts.

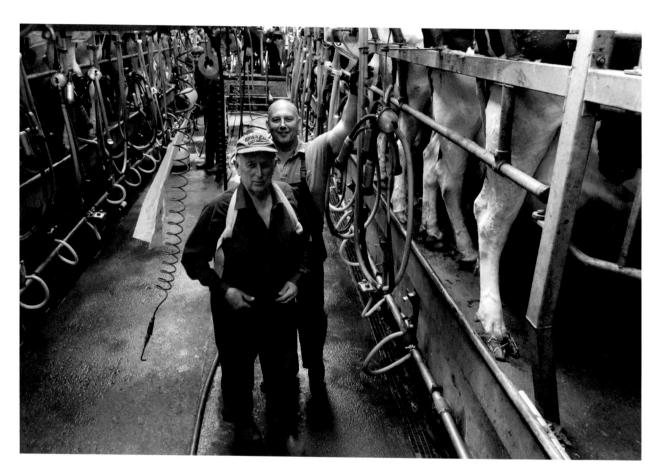

Lyn Morgan (right) and his father, Alan Morgan, in the milking parlour at Llangwm Farm. One memorable night during WWII, Alan's father, Selwyn Morgan of Llangwm Farm, hid a dead pig in his bed to hide it from the inspectors from the Ministry of Food. It had been slaughtered outside the village at North Nash Farm, owned by his friend Jimmy Lewis, and transported back to Llangwm Farm the night before the raid. Perhaps Selwyn and Jimmy imagined that by doing the deed at Jimmy's place, they would cover their tracks. The Ministry men searched but failed to find the pig. Selwyn ran a butcher's shop from the farm and often left early in the morning on foot with his two dogs to walk cattle back from as far as 20 miles away. With many families in the village fattening up a pig, Selwyn's deadly skills were often called upon, especially if a wedding or other celebration was in the offing.

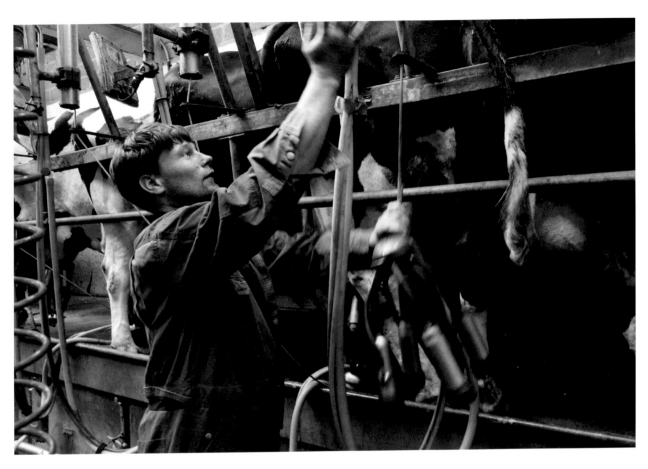

Lyn's son Daniel connecting up the milking apparatus. The cows are brought in for milking at six in the morning and three in the afternoon, which has been known to interfere with Daniel's sporting plans. He plays rugby and cricket for the village teams with an unrivalled commitment and is held in great esteem by those who know him. For a big man he displays extraordinary flexibility – his signature move in the bar after a game is a perfect, if eye-watering, gymnastic splits launched from standing on a chair.

Pages 68-69: **Sports day at Cleddau Reach School.** Sports days are enthusiastically supported by parents and grandparents as well as the pupils, who cheer on their teammates excitedly. There are three teams, Cleddau (red), Preseli (blue) and Ramsey (green), each captained by a boy and girl from Year 6. There are obstacle courses, sprints, the traditional egg-and-spoon race and the highly anticipated final event of the day – the long-distance run around the field. Then it's the turn of the parents, who are even more competitive than the children – a mum once snapped an Achilles tendon in the sack race.

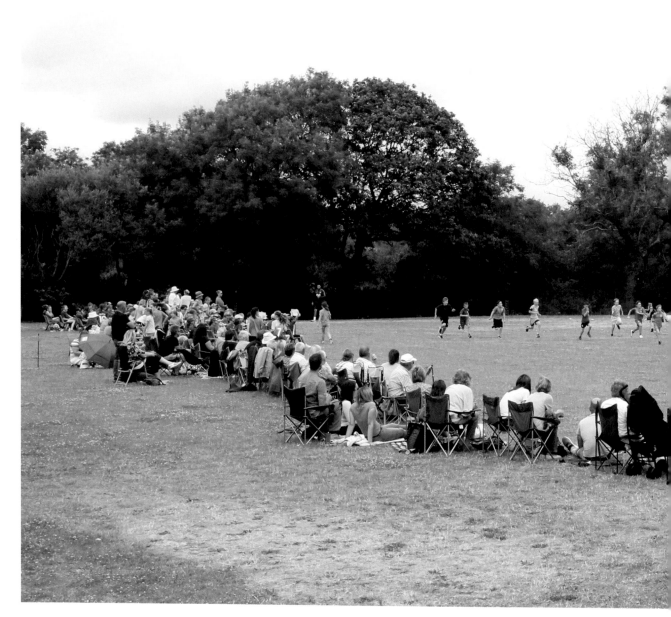

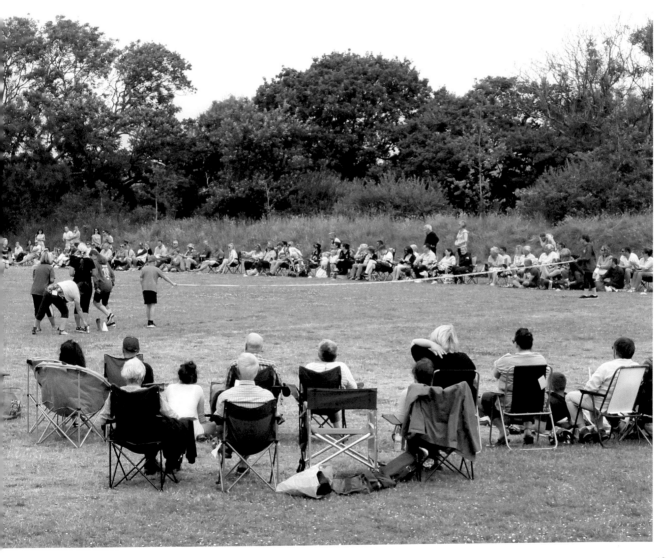

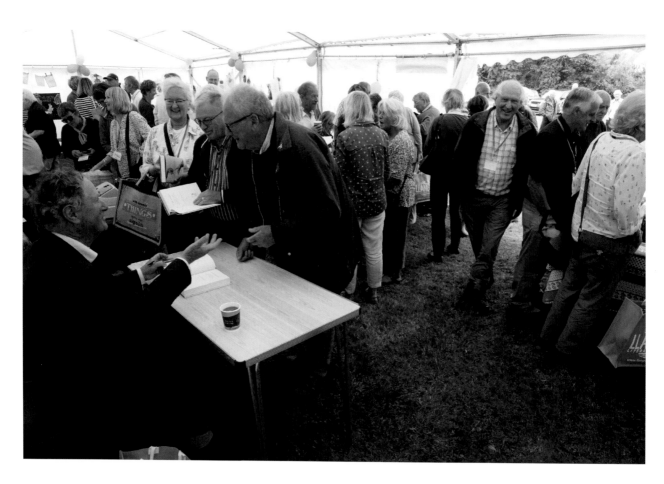

Author Ferdinand Mount (left) signs copies of his latest book after a talk in the village hall in the fourth Llangwm literary festival. The festival was set up by Michael Pugh and is run by an energetic and witty team of local volunteers. Michael is an international lawyer and academic who worked in Moscow for a number of years. He adored Russia so much that when he left it was on horseback to make the most of the glorious countryside for one last time. A fortuitous Google search for a cottage near the Cleddau brought him to Llangwm in 2015. The three-day literary event includes writers' talks, storytelling, art, workshops, feasting and dance. Previous line-ups have included Griff Rhys Jones, Eddie Butler and travel writer Dervla Murphy.

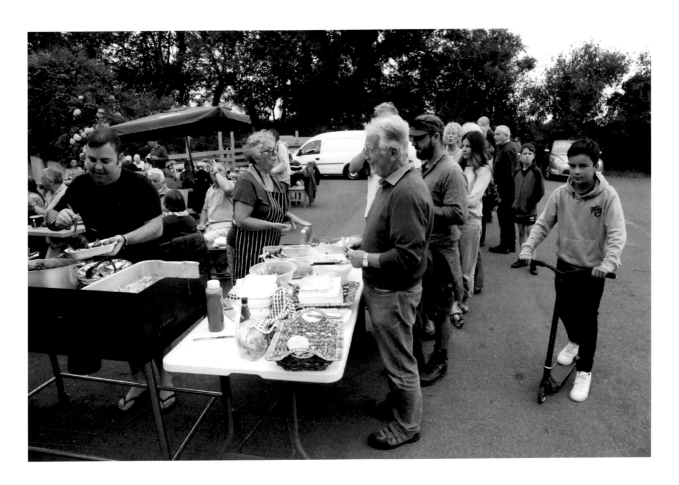

Matthew Evans (left) and Avril Platten
serving customers at a barbecue at
the Cottage Inn to celebrate the end of
another successful literary festival.

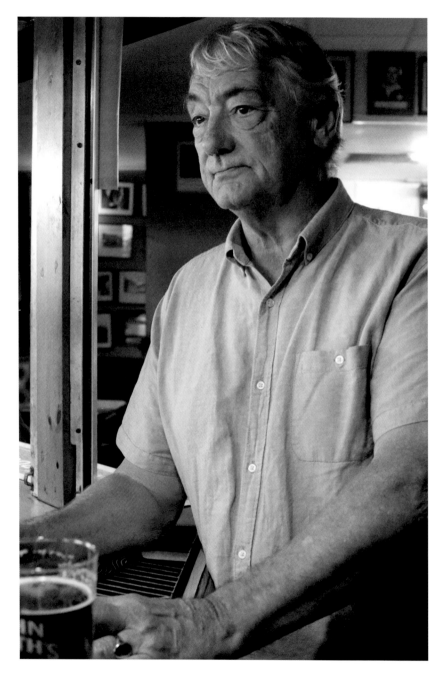

Graham Thomas at the bar during the literary festival's popular Poems & Pints night at Llangwm's rugby, cricket and social club.

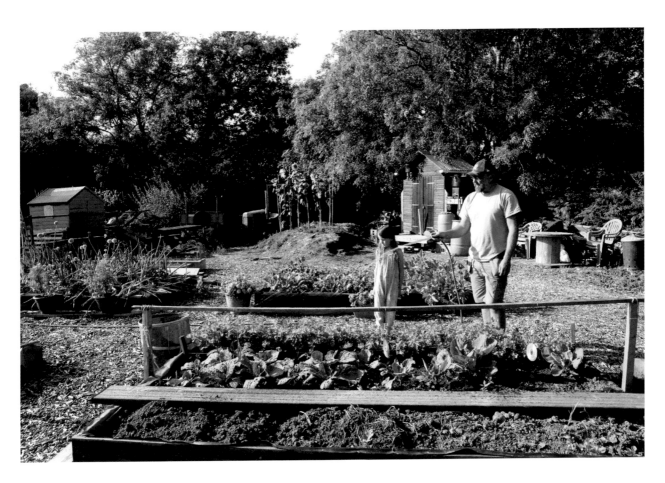

Darren Brick and his daughter watering their allotment. Llangwm's 18 allotments are located on the edge of the village at Deerland. The keen group of horticulturalists have come to accept the pilfering of gooseberries by blackbirds, mice helping themselves to the peas and other losses. There is even a resident badger that has taken a fancy to a mound of bark.

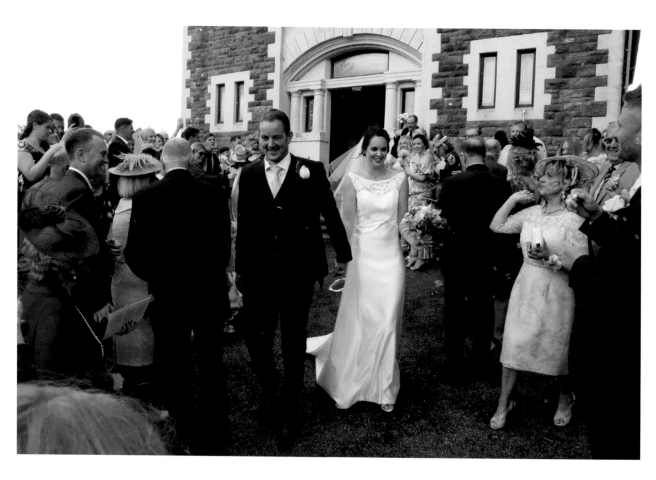

Newlyweds Andrew and Amy Brock
emerging from Galilee Baptist Chapel.

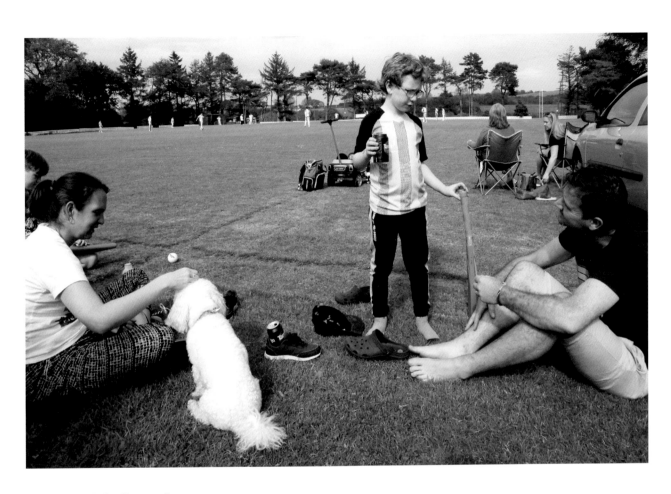

The O'Loughlin family spending an afternoon watching the cricket at Pill Parks.

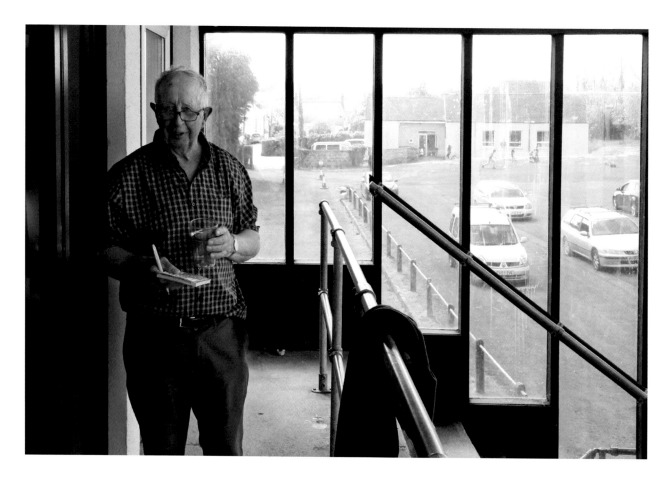

Dai Davies selling raffle tickets at the cricket. During home cricket matches at Pill Parks, a raffle is held to raise funds for the club. The winner of the draw receives a Sunday dinner box of a fresh chicken, donated by the Cottage Inn, and a selection of vegetables.

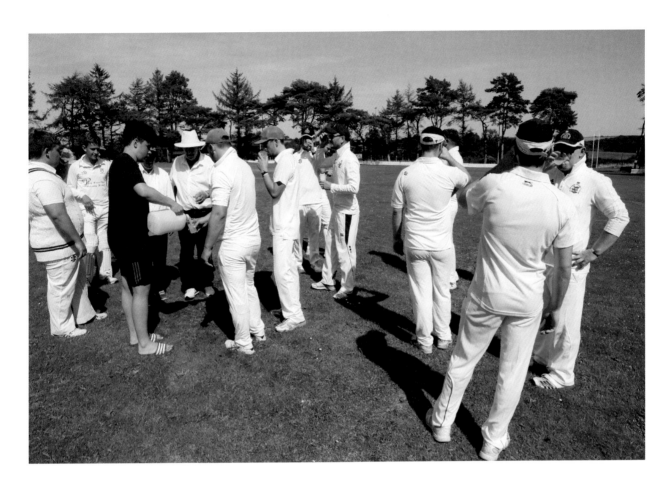

Refreshments are served during a
break in the last cricket match of the
season at Pill Parks.

AUTUMN

For most of the year Skyrme and David manage the farm with no outside help, but for a few hectic weeks in September it's all hands to the pump in a race to harvest the potatoes.

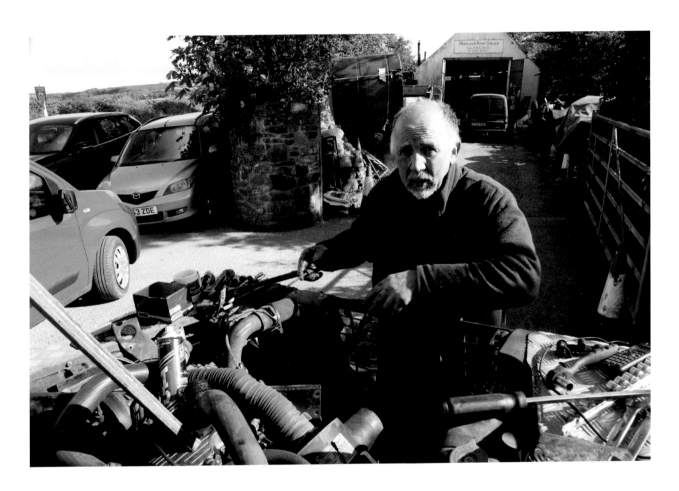

Frank Brick at Deerland Road Garage.
Frank was brought up on a farm in
nearby Burton and when not repairing
customers' cars he can often be found
tinkering with his collection of tractors.
His favourite is a Nuffield Universal
Four, which he keeps at the garage.

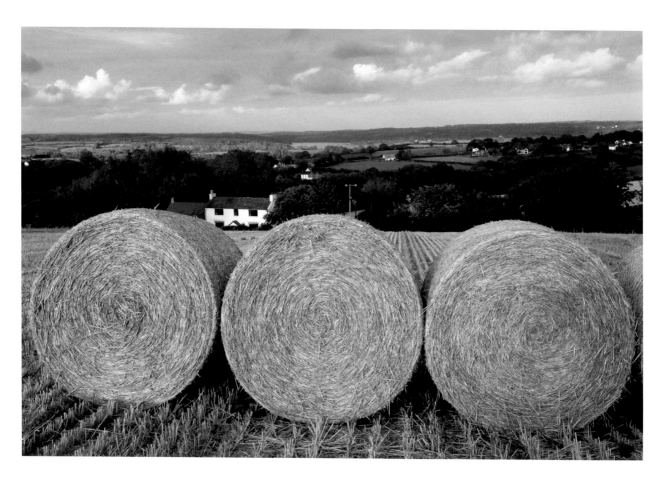

Hay bales at Great Nash Farm. Looking down to neighbouring North Nash Farm – owned by Skyrme Lewis – with the Cleddau Estuary in the distance.

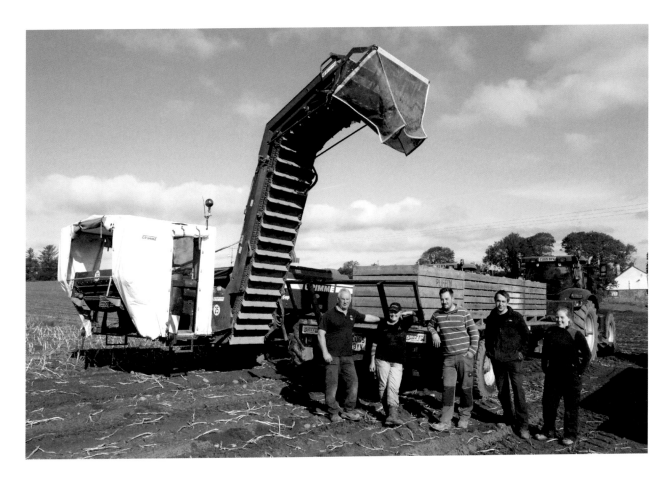

Skyrme Lewis (left) of North Nash Farm and his son David (centre). For most of the year Skyrme and David manage the farm with no outside help, but for a few hectic weeks in September it's all hands to the pump in a race to harvest the potatoes. Skyrme's sister Jane Reynolds (second left) pitches in each year, and also helping were Jane's daughter Bethan Reynolds and Chris Lewis (no relation to Skyrme).

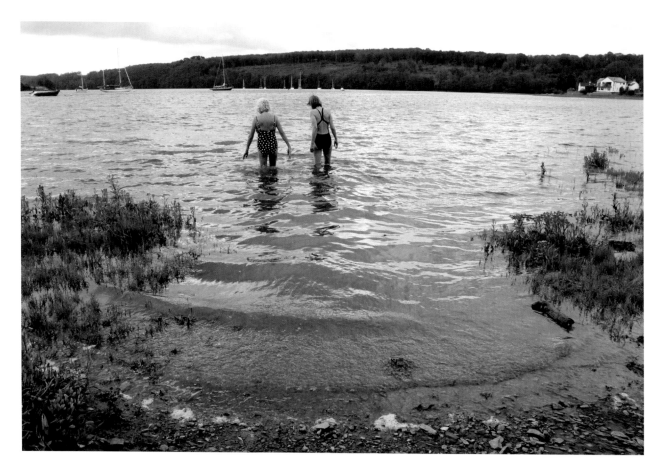

Swimming at the Cunnigar. Angela Davies (left) and Arian Anger take a morning dip in the estuary; Angela had recently completed a wild swimming tour of Scotland with her partner, Paul, swimming the lochs while Paul sat on the bank in a deckchair with a cup of tea and the papers. In summers past, the Cunnigar was a popular spot with local families, especially from nearby Glan Hafan, who would bring picnics down to the shore and spend the day relaxing and socialising. The children whiled away the hours swimming, mud-sliding and shrimping – the odd mud-fight wasn't unknown – and as evening drew in a bonfire was often lit on the shore. Who needed the coast when there was the 'Black Tar Riviera'?

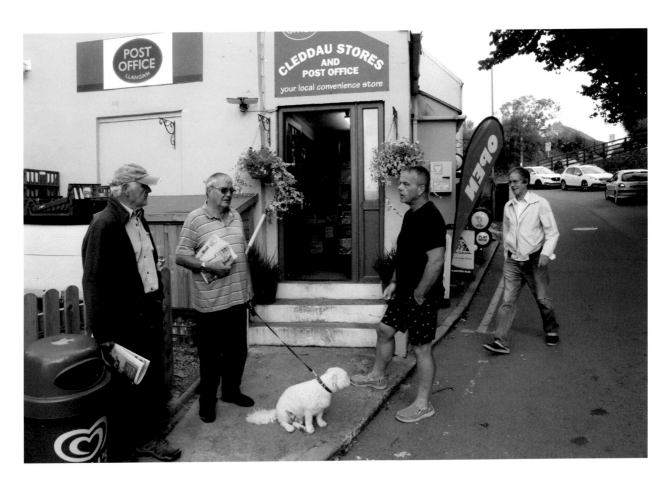

Catching up on the news outside the shop.

P84-85: **Gareth Jones on the Cleddau Estuary with the village in the background.** When he was a teenager, Gareth accompanied his father on his boat during the herring season. In the space of a few springtime weeks villagers could accumulate a small fortune, '...enough to buy a new van or pay for an extension on the house.' During one trip the boat was very low in the water due to a large catch. 'We were taking on water and only just made it back,' Gareth describes. 'I was terrified. Never went out with him again.' A couple of years before Gareth's experience, a boat from the village had gone down with loss of life.

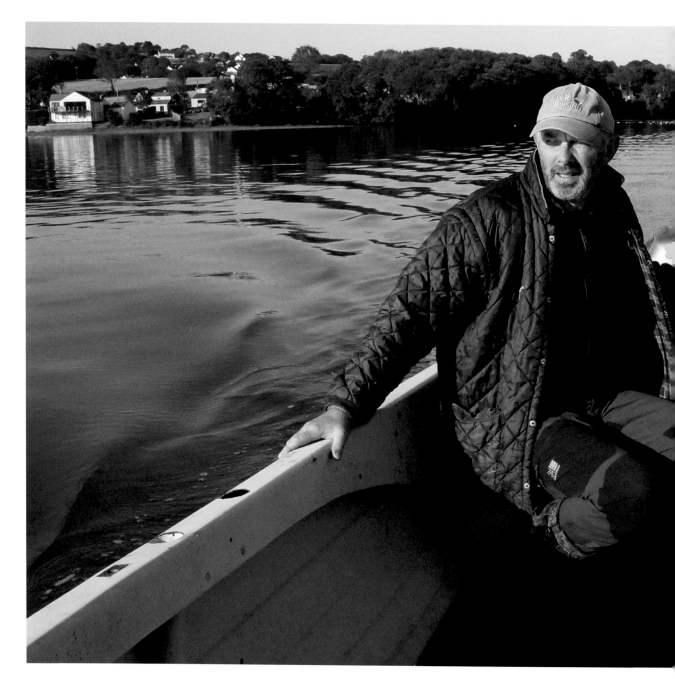

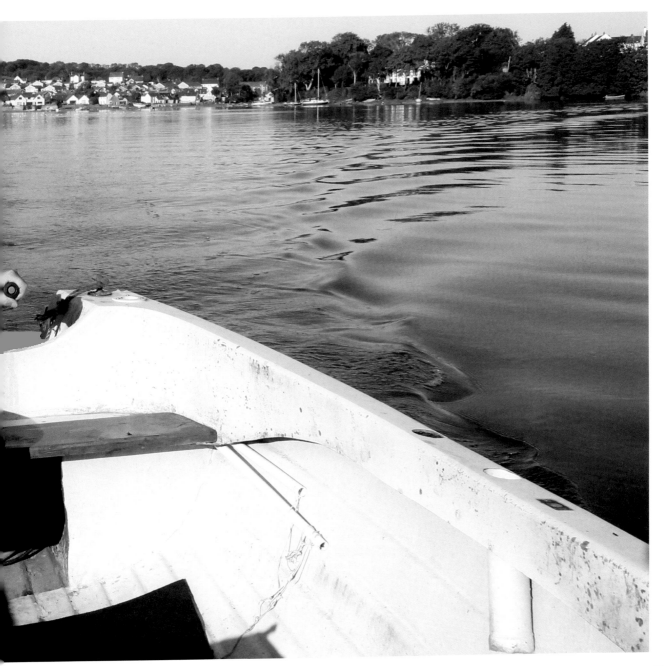

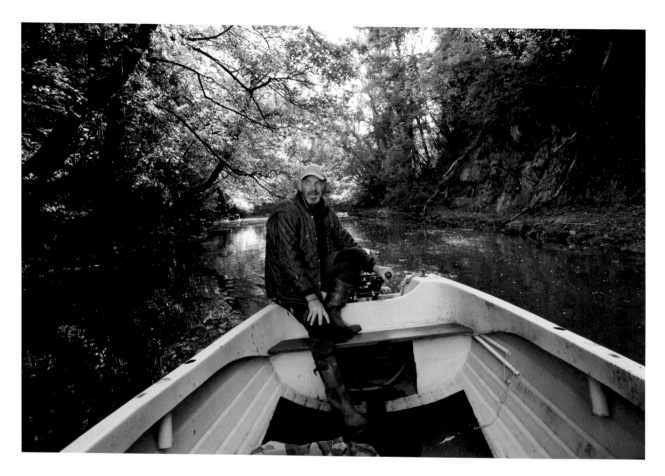

Abandoned quarry on the Cleddau Estuary, opposite the entrance to Guildford Pill. As a boy, Gareth would head off for hours with a pair of binoculars and a pocketbook on native birds. Scouring the shore, fields and woods around the village, he made notes on species, returning home to draw and paint what he had seen. When he left school he aspired to study art at college but instead was encouraged to pursue a career as a plumber. Having retired from running a successful business, Gareth now regularly heads out onto the water in search of inspiration for his art, producing beautiful and finely detailed watercolours of the local wildlife.

Cycling along Rectory Road. The stepping stones, or 'steppies', as they're affectionately known, can be seen on the right of the photograph. The current concrete blocks replaced the original large, flat stones some 20 years ago; an advantage of the raised blocks is that you can cross when the water's deeper. Before the stone bridge was built, the stepping stones would have been the main route on foot across Guildford Pill.

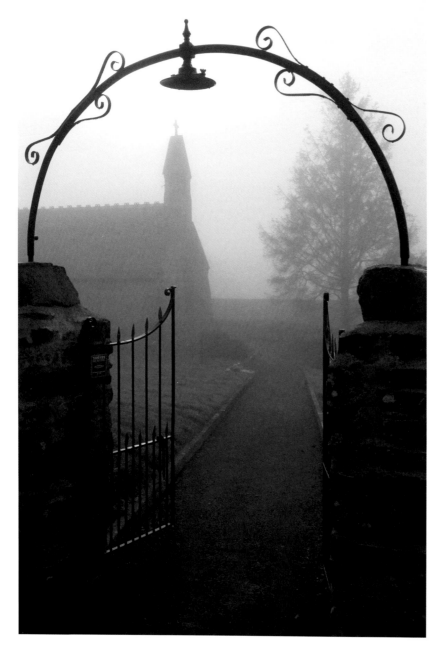

St Jerome's Church. There has been a church here since at least 1185, following the arrival of the Flemings and the Anglo-Normans into South Pembrokeshire and the subsequent displacement of the native Welsh to the north of the county. There are surviving architectural features which point to the existence of a church on this site before the invaders came.

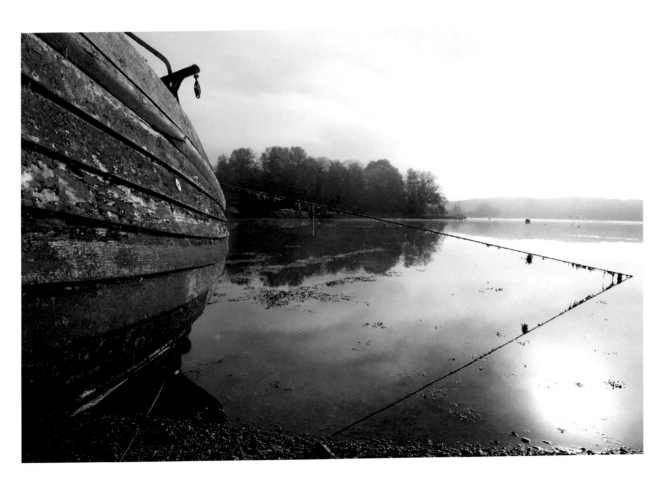

Early morning at Guildford Pill. A mile upstream the Cleddau Estuary splits into the Eastern and Western Cleddau rivers. A further five miles up the western branch brings you to the county town of Haverfordwest, which once had a busy port that traded with Bristol and further afield. The port went into decline after the coming of the Great Western Railway to Haverfordwest in 1856.

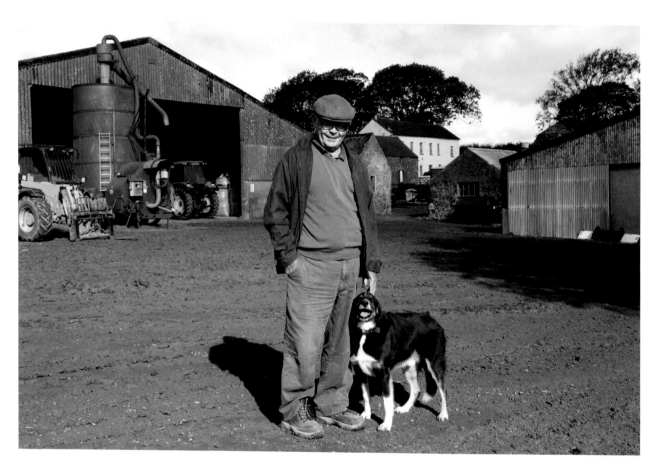

Mel Scale at Great Nash Farm. Mel's father took over Great Nash – not to be confused with nearby North Nash – in the 1950s and though approaching 80 Mel still helps his son Will on the working farm. A quarter of a mile outside the village, Great Nash was once the seat of the lords of the manor, though these days, with its stone outbuildings, corrugated sheds, tractors and assorted paraphernalia of farming, you would be hard-pressed to guess at the site's previous importance. A well-preserved medieval dovecote and the extensive ruins of a 16th-century manor house, built on the remains of an earlier fortified building, are reminders of Great Nash's past.

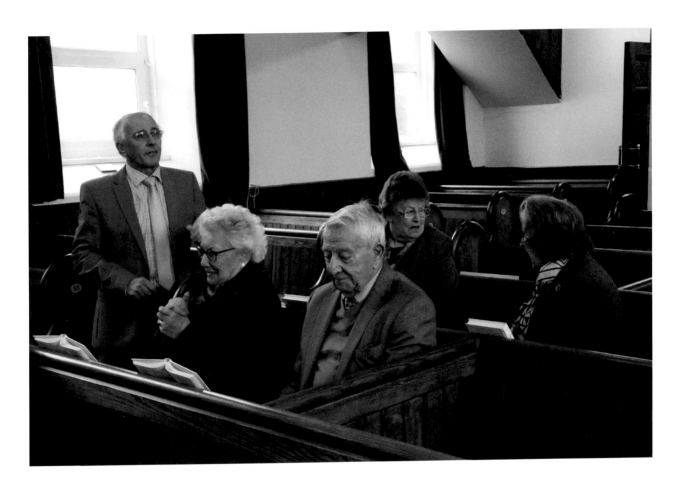

**Members of the Wesleyan Methodist
Chapel attending Sunday service.**
The chapel is one of two in the village,
the other being Galilee Baptist Chapel
in Guildford. Both were built to
accommodate the large congregations
of the time; sadly, these days most of
the pews are empty.

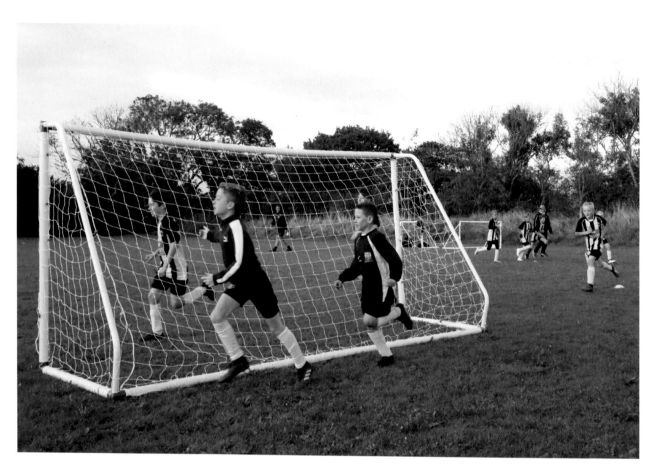

Llangwm Lions U12s football team
warming up before training.

Carpenter Darren Brick (right) and his workmate Dean Brinn painting Galilee Baptist Chapel. Although there are many small businesses like Darren's that operate in the locality, each weekday a steady stream of cars leave the village in different directions, taking their occupants to jobs around the county and beyond. Leaving the village to work is not a new phenomenon – the 1960s saw a double-decker bus collecting men from the Green to work at the Royal Naval Armaments depot at Milford Haven, and until the 1920s many were employed at the Royal Naval dockyard at Pembroke Dock. Before then, generations of men, women and even children went down the mine in Hook, a mile away, or rowed across the estuary to another mine at Landshipping.

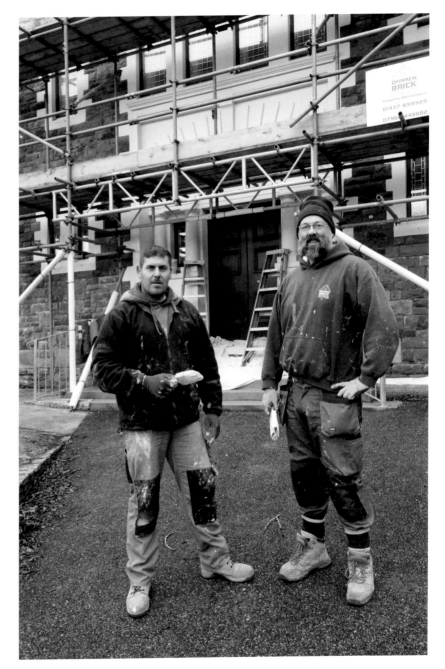

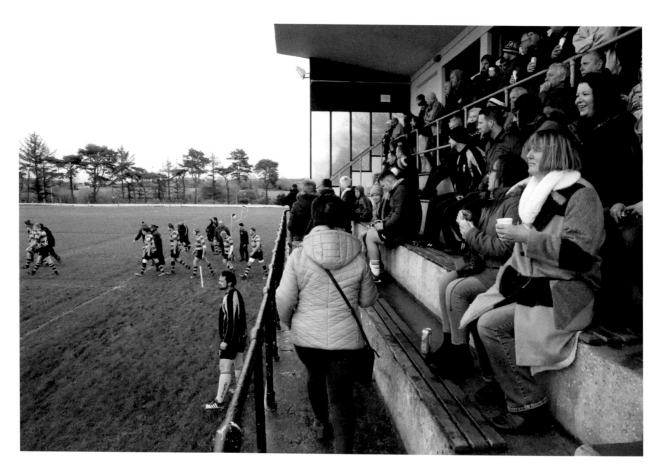

Llangwm seniors taking to the pitch for the inaugural Johnny James Memorial Trophy match against St Davids. Johnny James, ex-hooker and fearless captain of the Llangwm team, had recently passed away at too young an age. With his family connections to St Davids, the two clubs decided to inaugurate an annual cup in Johnny's memory – the Johnny James Memorial Trophy, played over two legs, home and away. The match drew a huge crowd.

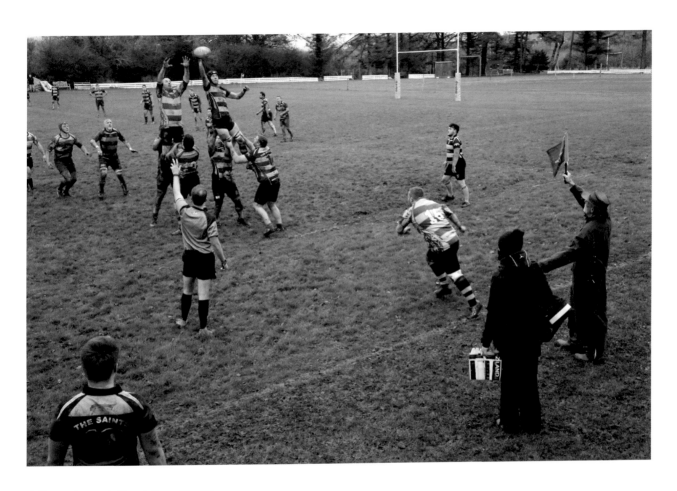

A line-out goes to the visitors. The Wasps
are playing in their second team kit of
blue and white, thereby allowing St Davids
to wear their traditional club colours of
black and amber – practically identical to
Llangwm's first kit.

Pages 96-97: **The Llangwm team heading
to the changing rooms having won the first
leg of the memorial trophy 22-10.**

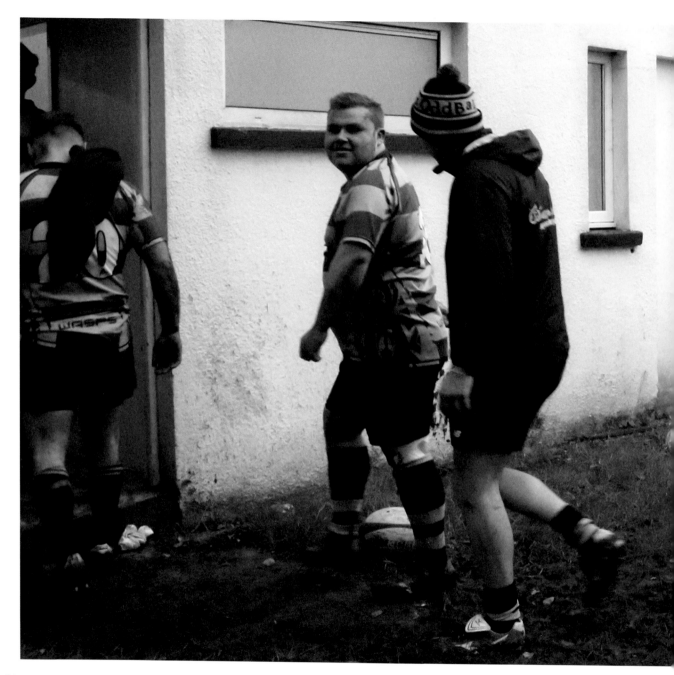

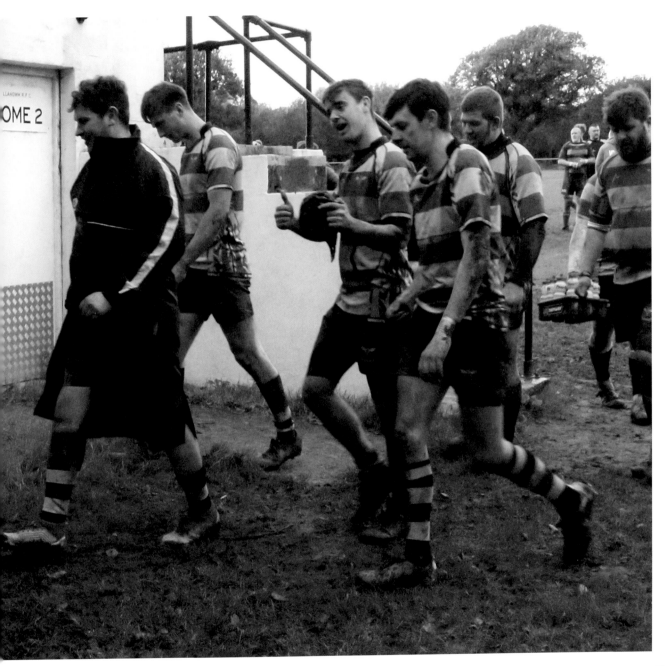

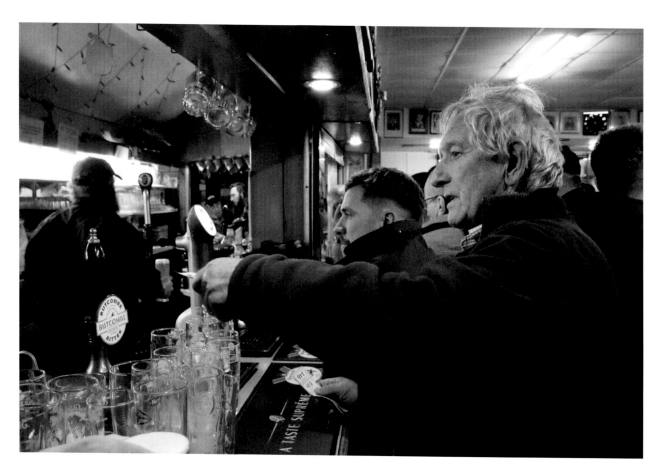

Owen John in the club after the game against St Davids. Owen left the village as a young man to teach in London. He also worked on a kibbutz in Israel, motivated – at least partly – by some great diving spots. He went on to run a field centre in Kent, accommodating disadvantaged children from inner-city London, but he never forgot Llangwm – his home. At 5 am on the first day of the summer holidays he'd pack his family into the car and head to Llangwm, only returning to Kent the day before the start of the new term. Retiring to the village with his wife Val, they lived in what had been his grandfather's cottage and fulfilled a lifelong dream: they bought a yacht, sailed it to the Mediterranean and spent their summers exploring the Greek islands, Turkey and other coasts, inviting family and friends to join them on their adventures. Sadly, since this photograph was taken, Owen has passed away.

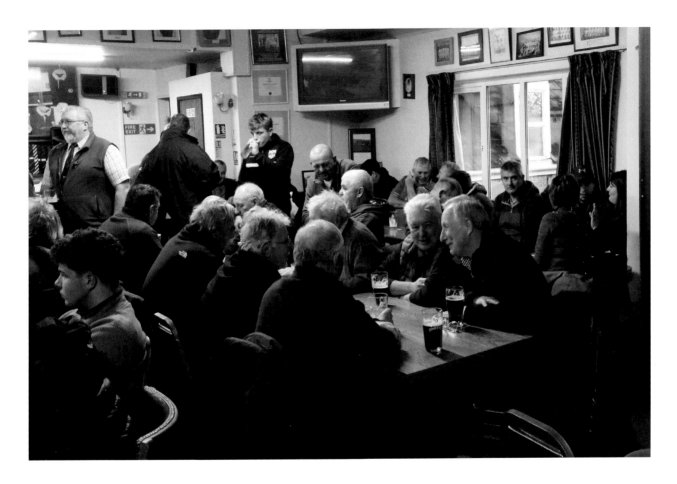

The camaraderie in the rugby club is especially buoyant when the St Davids team and supporters visit.

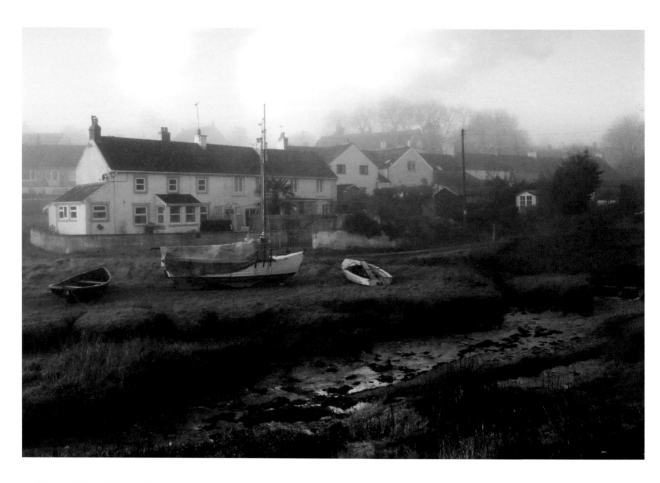

Guildford Pill and the back of
Williamston Terrace.

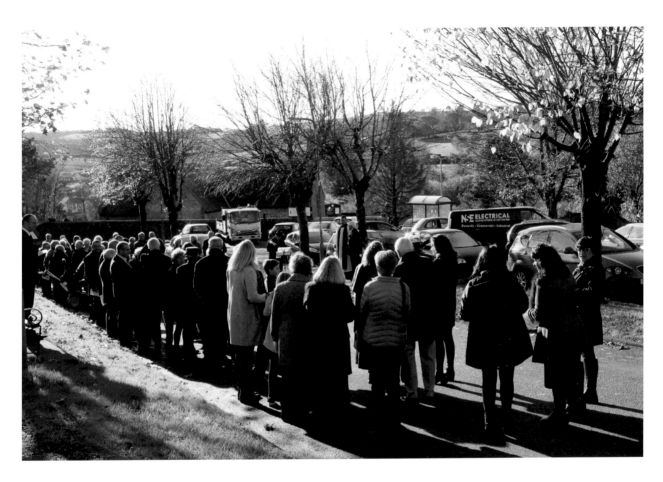

The Remembrance Sunday service at the war memorial on the Green, led by the Reverend Marcus Zipperlen, vicar of St Jerome's Church. One of the names on the memorial is that of Stoker 1st Class James Henry Skyrme. James lived in our street, Williamston Terrace (perhaps in our house), and enlisted in the Royal Navy aged 19 in 1900. He was one of the very first British servicemen to be killed in WWI when his ship, HMS *Amphion*, struck a mine in the North Sea on 6 August 1914 and sank. The war was only 32 hours old.

WINTER

...the foreshores at Black Tar, the Cunnigar, Edwards Pill and Guildford Pill would have been strewn with the distinctive wooden Llangwm boats in the village's past.

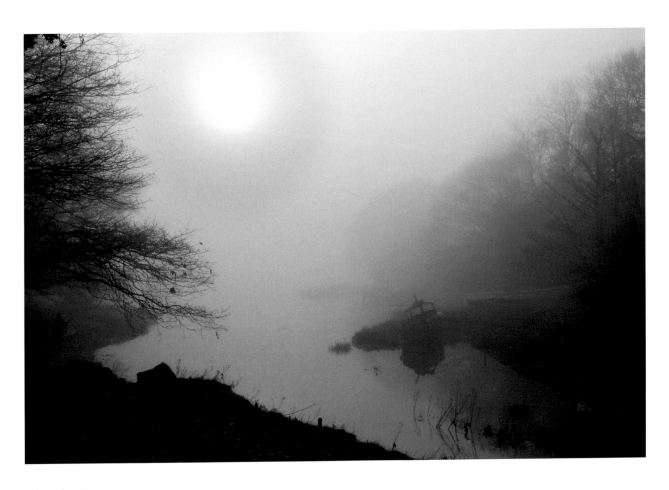

Edwards Pill.

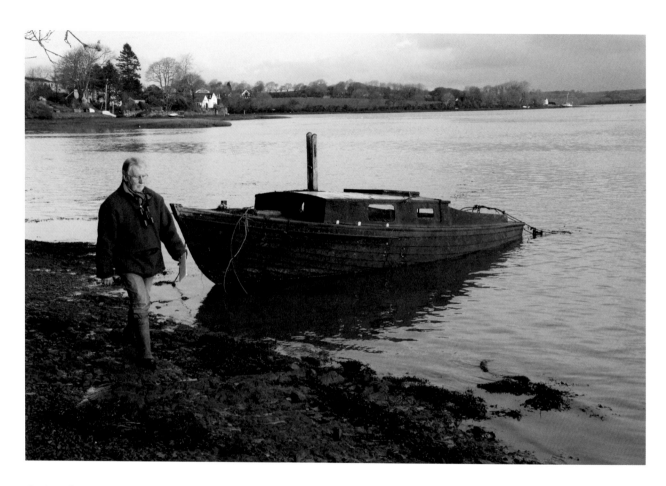

Graham Brace at Port Lion. Each morning, weather permitting, Graham walks the shoreline around and near the village. As an artist he's looking for inspiration and as an ornithologist he's on the look-out for birds. When Graham was 13 years old, the naturalist and author John Barrett gave a talk to his class at Milford Haven Grammar School and he's been hooked on birdwatching ever since. The rarest bird he's recorded in Llangwm is a squacco heron, which had strayed well away from its eastern Mediterranean habitat. For a number of years the dilapidated boat was an abandoned feature, but not long after this photograph was taken Storm Dennis broke the rotten structure up and swept it away, leaving little trace.

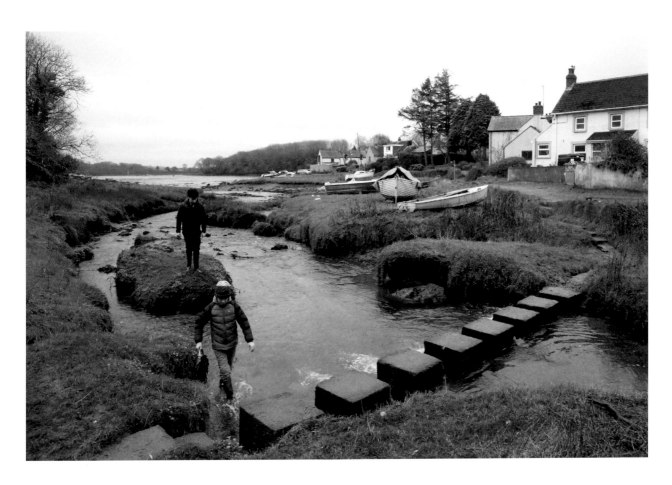

Mud-larking in Guildford Pill. My boys have been drawn to the pill behind our house since they were young. Harry, in particular (closest to the camera), has dug out numerous finds from the mud, filling a stack of boxes in our garden shed. The side extension on the cottage closest to the stepping stones was once Gus Brown's sweet shop.

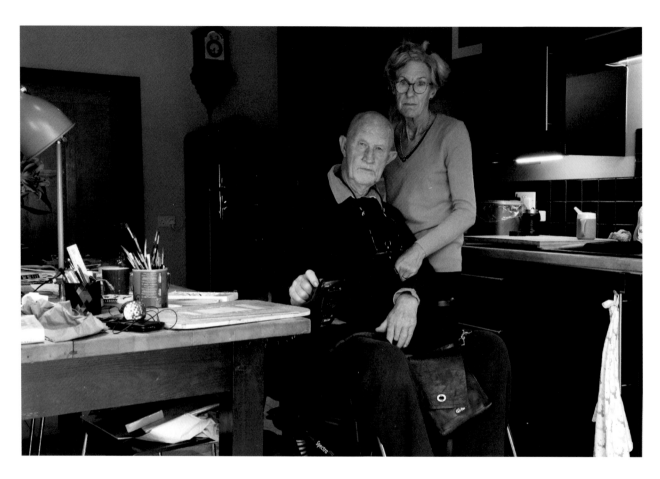

Jacqui and Patrick Wordsworth at home in Llangwm Ferry. Patrick has been painting; just one of his many and varied interests. The antiques, collected during a lifetime, make the house an interesting and stimulating place to visit. He used to hold a black powder (gunpowder) licence which, combined with a mischievous interest in pyrotechnics, resulted in numerous explosions in and around the property, not all of them intended. His love of engineering to solve problems was invaluable when he was diagnosed with muscular dystrophy, and he designed and built what was, in effect, a rowing machine for the river that accommodated his impaired physical capabilities so that he could continue to row. I often heard the roar of an engine and looked out of my house to see him zip past on a motorcycle trike that, again, he had designed and built. Sadly, since the photograph was taken, Patrick has passed away.

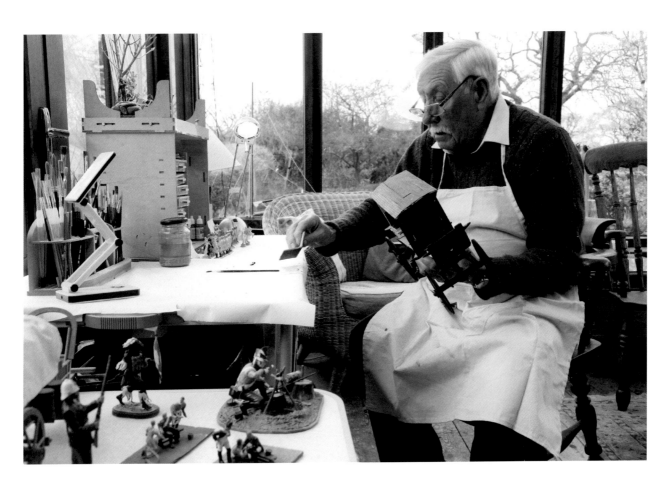

David Mills at home in Butterhill.
David has been model-making since
he was a boy, when he would construct
'plank on frame' sailing boats and
balsa wood aeroplanes. He progressed
to smelting metal in order to mould
figurines and has made more than 20
miniature hand-painted chess sets over
the years, giving many away to family
and friends. With pride, he showed me

a diorama of the Battle of Rorke's Drift,
which I found fascinating. On nights
when he can't sleep, he can be found in
the conservatory working on his latest
project.

Black Tar at high tide just after dawn.
Is Black Tar named after the tar which
was once applied to Llangwm boats to
preserve them? Or is it a mutation of
'bleak' or 'black tor', in reference to
the seaweed-covered rocky outcrop by
the slipway? It's a bit of a mystery. In
contrast to the more modern boats in
the photograph, the foreshores at Black
Tar, the Cunnigar, Edwards Pill and

Guildford Pill would have been strewn
with the distinctive wooden Llangwm
boats in the village's past.

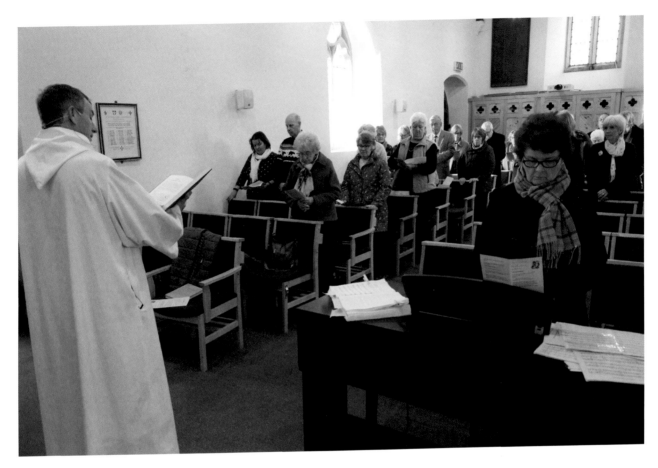

The Reverend Marcus Zipperlen of St Jerome's Church leading an Advent service in the run-up to Christmas.
A previous vicar of the parish, the Reverend Jane Goupillon, became so concerned by the physical deterioration of the church – using buckets to catch drips from a leaky roof can be dispiriting – that she launched a fundraising drive to restore the building. Realising the enormity of the task, she asked one of the parishioners, Pam Hunt, if she could take over the appeal as she said Pam was 'good at these things'! The appeal eventually raised £432,000, with contributions from the National Lottery's Heritage Fund amongst other donations and fundraising activities. The church closed for a two-year renovation, reopening in 2017. Sadly, Jane died in 2014 and never saw the incredible transformation of her church.

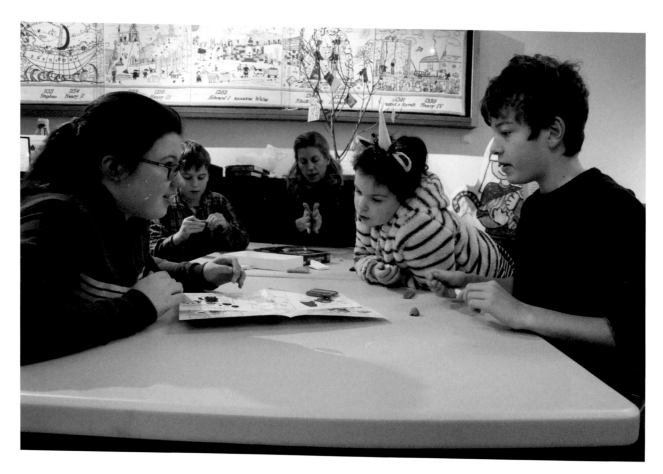

St Jerome's Sunday school. While Marcus leads the service, his wife Polly oversees a Sunday school craft session in the north transept of the church. On the wall behind Polly is the Talking Tapestry of Langum (there have been many spellings of the village's name over the centuries), a five-metre-long audio visual work illustrating the village's medieval Flemish links.

The tapestry was designed by local artist Fran Evans based on drawings by children from Cleddau Reach and Hook primary schools. Using Fran's designs, a team of embroiderers set about creating the tapestry, the stitching parties fuelled by endless cuppas and lots of chat and laughter. Produced as part of the ambitious Heritage Llangwm project, the tapestry was installed in the church

to coincide with the reopening of St Jerome's after its renovation.

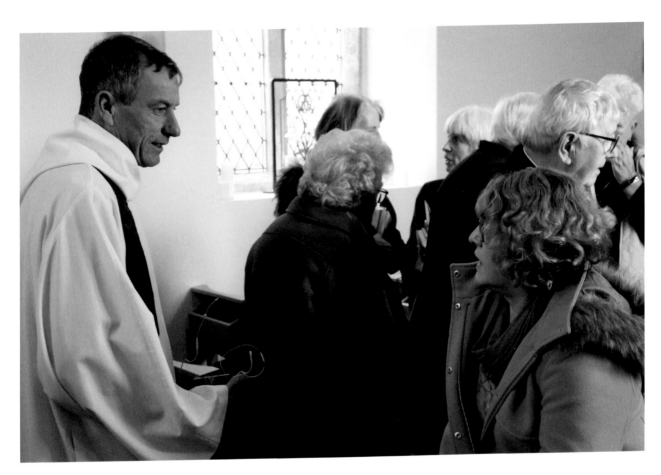

After the service, tea and coffee is served, giving Marcus an opportunity to chat with parishioners. As a child Marcus was taken by his mother to church, though it left little impression on him and as he grew up he was influenced by his older brother's interest in scientific thinking, which encouraged Marcus to believe that religion was baseless. After studying environmental science at university he worked as a builder with a friend and, as he had a lot of spare time, decided to read the Bible to confirm his belief that it was without foundation. Instead he found himself being drawn into the gospels and the work of Christ; the Bible had an increasingly profound effect on him. Conflicted by his growing Christianity, he lived a semi-secular existence working as a biologist at the Centre for Alternative Technology in Machynlleth while attending church and retreating to a friary for long periods to pray and focus on God. Finally, with the support of his wife Polly, he committed to the church and became a vicar in 2013 at the age of 42.

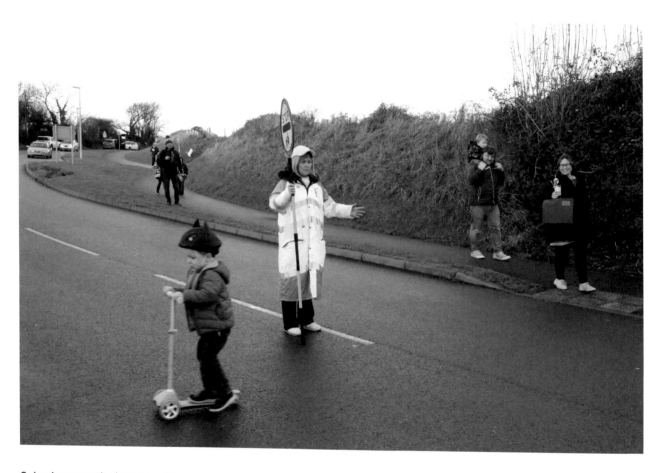

Going home on the last day of the
Christmas term.

Residents at River View get into the Christmas spirit.

Page 114: **Julian Platten behind the bar of the club on Christmas Day morning.**
My eldest son Charlie was with me on the Green as I was taking photographs when I noticed that the club was open. Besides Julian, no one else was in there. He said, 'I open up for a couple of hours, just in case someone's on their own and wants a bit of company.'

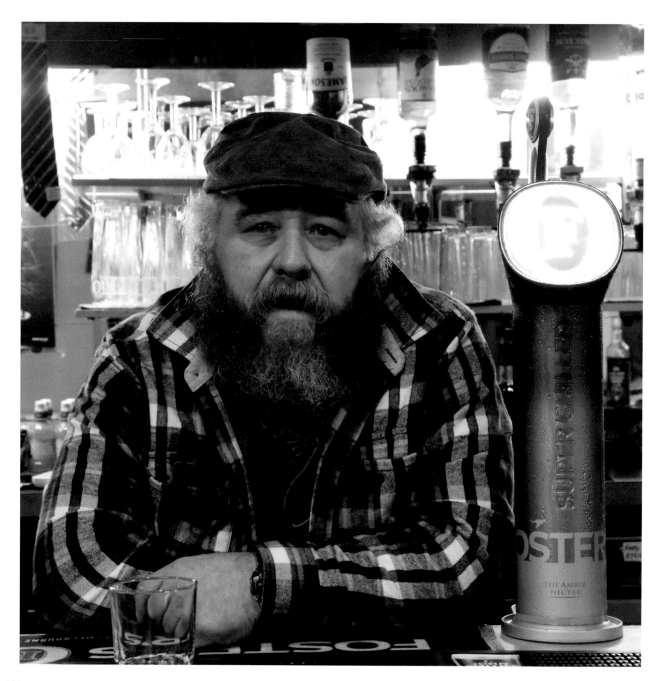

LOCKDOWN

Exercising with Joe Wicks before the boys logged on to online schooling or Anna switched on her work laptop. By Easter, Joe had been dumped in favour of a morning bike ride to Black Tar.

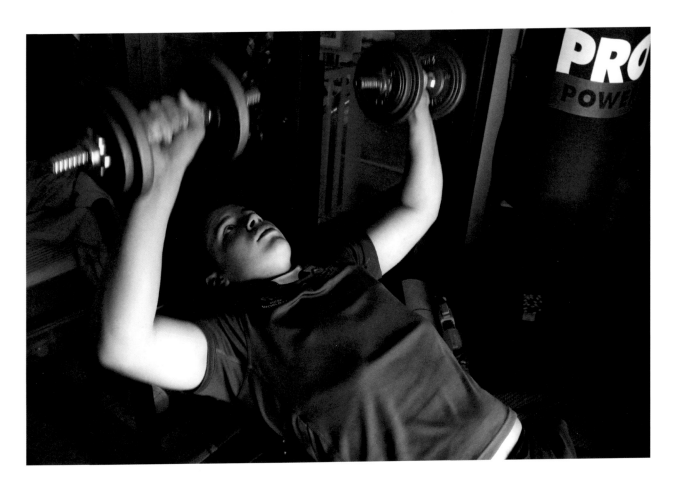

As lockdown loomed, I asked my dad
to get my old weights and bench down
from his attic for Charlie to use.

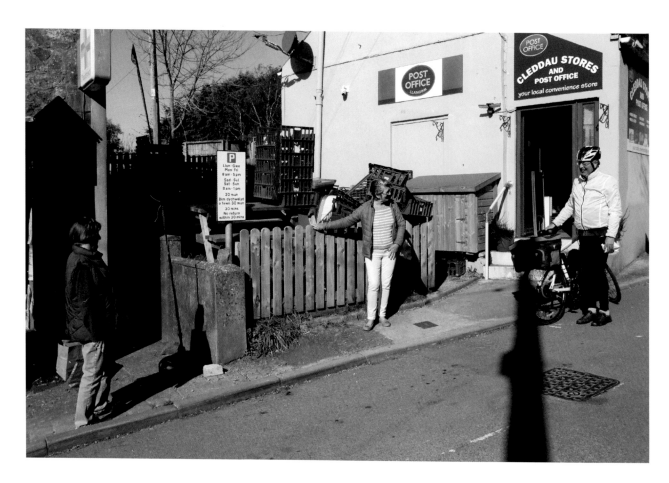

A socially distanced queue waiting patiently outside the shop, adhering to their one-out, one-in policy.

Anna cutting Harry's hair.

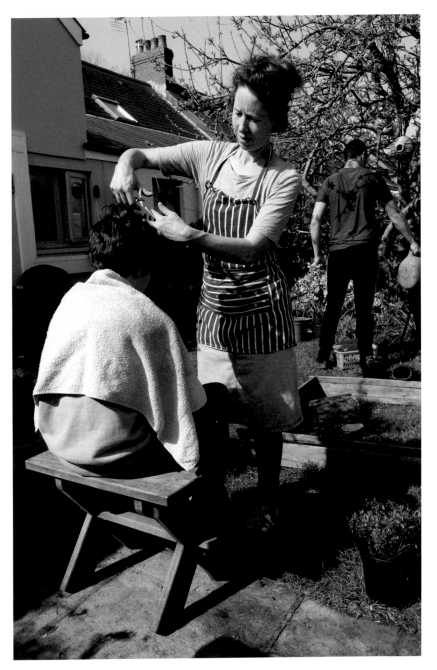

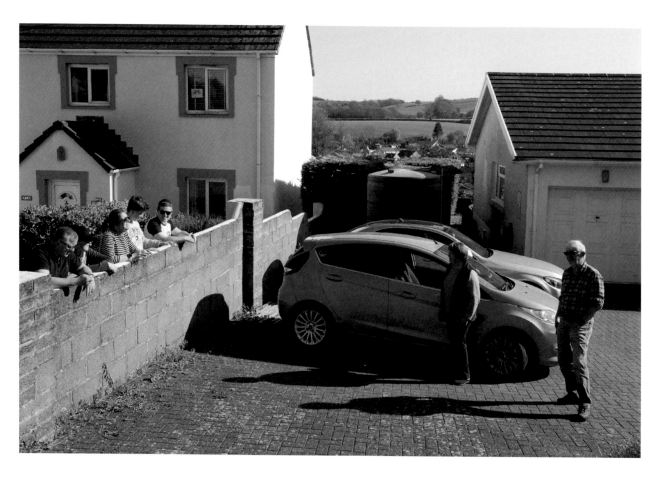

Pam Asson and her family enjoying a chat with her parents (and next-door neighbours) Barry and Janet Childs. Barry and Janet were born in the village – his childhood home was a cottage at the Gail, while Janet's parents ran Cleddau House, the shop where you could buy 'anything and everything'. Aside from a few years in Cardiff – Barry at university and Janet at teacher training college – they have always lived in Llangwm. On retirement Barry was deputy head of Dyffryn Taf comprehensive in Whitland while Janet had taught in a number of primary schools, ending her teaching days in Llangwm School. They have witnessed many changes in village life, one of which is the increase in road traffic. 'There were so few cars when I was young,' says Barry. 'We could play cricket in the middle of the road at the Gail and were scarcely disturbed the livelong day.'

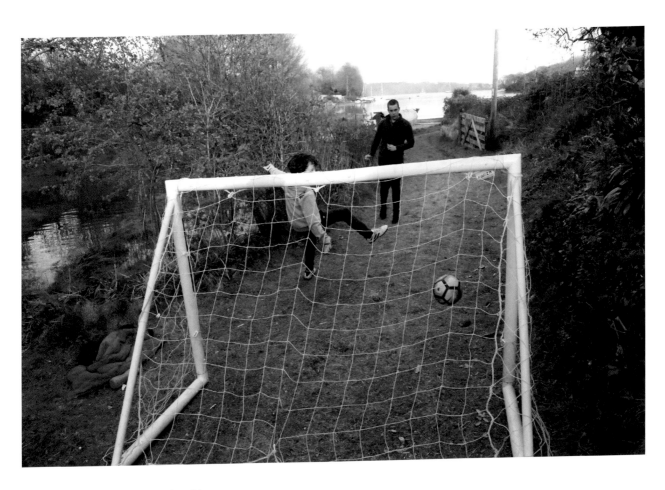

The boys play football as a rising tide
threatens to swamp the pitch.

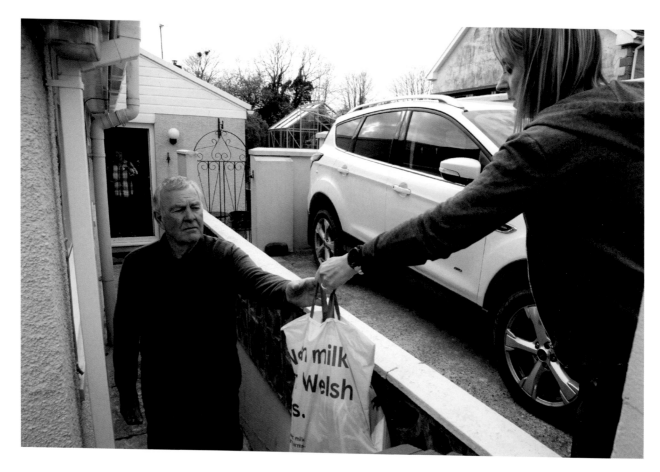

Dave Golding's wife Hannah making an early evening food delivery to Mike Roberts. Cleddau Stores staff and their helpers were tireless in delivering essential provisions to many people in the village throughout lockdown. Most days, Hannah or Matthew Evans from the Cottage Inn went to the supermarkets in Haverfordwest to supplement supplies from the shop.

Dave's son Konal also helped with deliveries. As the deputy headteacher of a primary school, Hannah's daytime hours were dedicated to checking on the welfare of her pupils and teaching them online, while Matthew also worked in a care home. Other volunteers included Liz Beresford and fellow 'papergirl' Kim Sandford, who delivered newspapers in the mornings.

Harry having a Zoom piano lesson with his teacher, Sam Howley.

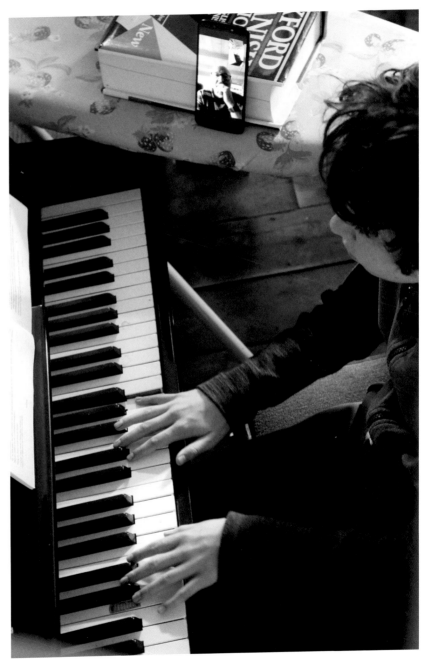

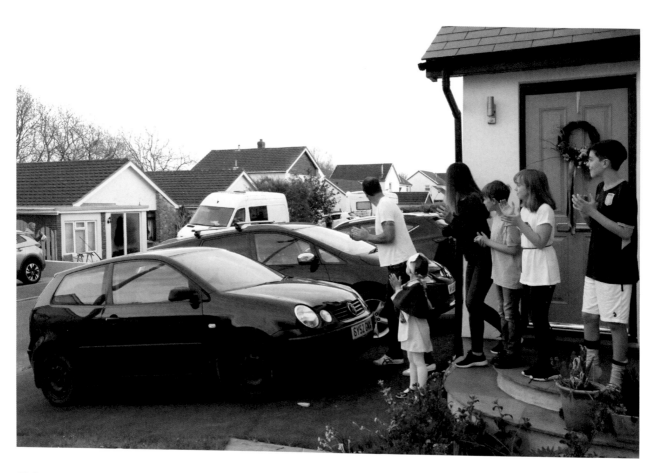

Richard and Tasmin Nash and their
children come out to applaud the NHS
and key workers one Thursday evening
at eight o'clock.

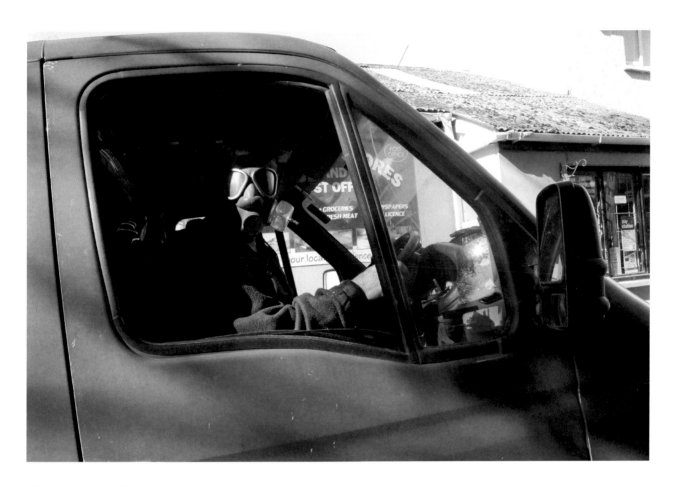

Dilwyn George – a little tongue-in-cheek – taking precautions against the virus.

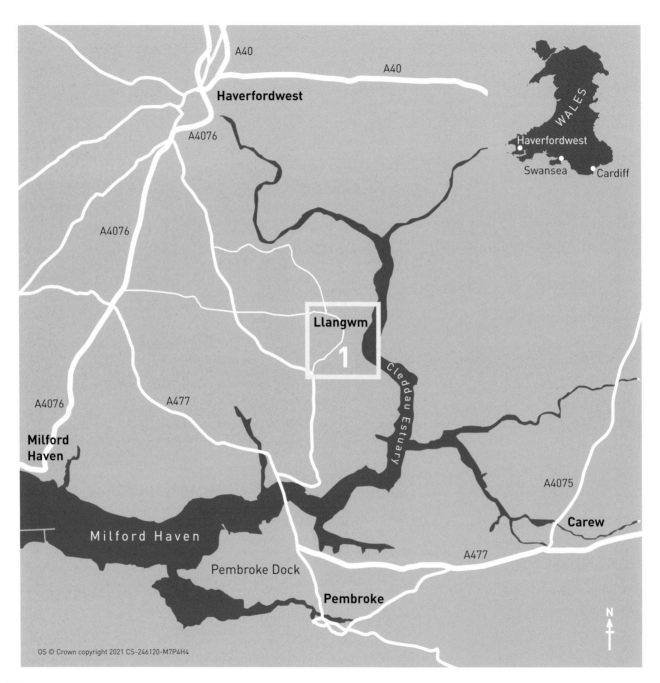

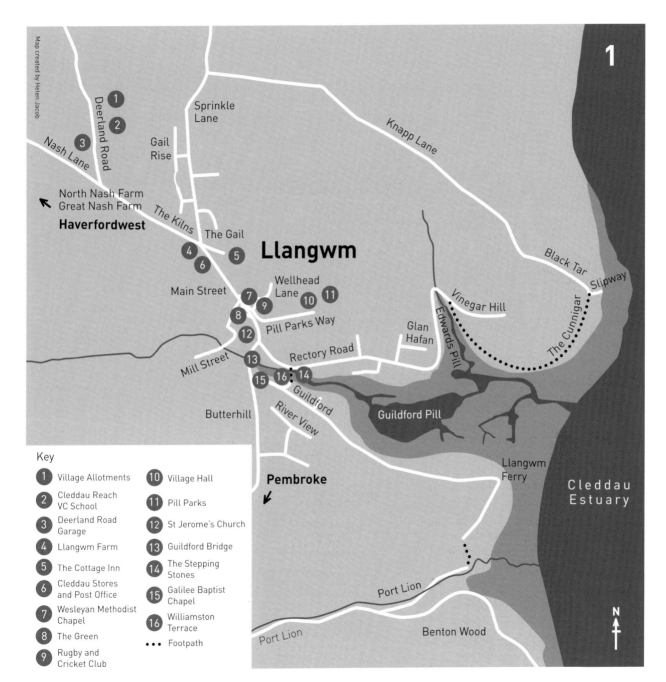

Key

1. Village Allotments
2. Cleddau Reach VC School
3. Deerland Road Garage
4. Llangwm Farm
5. The Cottage Inn
6. Cleddau Stores and Post Office
7. Wesleyan Methodist Chapel
8. The Green
9. Rugby and Cricket Club
10. Village Hall
11. Pill Parks
12. St Jerome's Church
13. Guildford Bridge
14. The Stepping Stones
15. Galilee Baptist Chapel
16. Williamston Terrace
••• Footpath

ACKNOWLEDGEMENTS

This book would not have been possible without the people pictured within it.

Thank you to those who entertained my requests to photograph them at home, at work and at play. Your enthusiasm for the project and patience were much appreciated.

For those of you who happened to be in the shop, at the pub, on the cricket and rugby pitches, walking down the street, or wherever else it was that I ambushed you, a big thank you for not running away!

Thank you for everyone's personal anecdotes and stories that brought the accompanying captions to your photographs alive.

Thank you to Ian Jacob and his daughter Helen Jacob for designing the magnificent map of the village and its environs, and thank you to Ian for the tales of village life from the past which embroidered a number of captions.

Thank you to Graham Stephens for fact-checking the historical content and saving my blushes.

Thank you to Michael John for allowing me to tap into his local knowledge and being especially helpful with all things rugby related.

Thank you to Barry Childs for his tales of the Llangwm of his youth.

Thank you to Jane Brock, Dave Golding, Pam Hunt and Darren Brick for supplying answers to a host of disparate questions regarding names, events and other minutiae.

Thank you to Margaret Brace for proofreading the copy with a forensic eye.

Thanks also to my publisher Peter Gill and the team at Graffeg for making this book happen: designers Joana Rodrigues and David Williams, Daniel Williams for copyediting and Matthew Howard for editorial advice, sales and distribution.

Any errors or omissions in this book rest solely with me.

And finally, thank you to Llangwm for being Llangwm!

DAVID WILSON

David Wilson is an acclaimed landscape and documentary photographer. Travelling around his native Wales, he photographs its places and people, capturing a proud and fascinating country. The author of many books, his next publication will be his memoir, *An Unlikely Photographer*. He lives with his family in Pembrokeshire.

Wales A Photographer's Journey
Large format, 300 x 300mm
- Hardback, 160 pages
- ISBN 9781905582594
- £35.00
- Publication June 2012

Pembrokeshire
Large format, 300 x 300mm
- Hardback, 120 pages
- ISBN 9781905582921
- £30.00
- Publication September 2013

Compact edition, 150 x 150mm
- Hardback, 128 pages
- ISBN 9781905582938
- £9.99
- Publication August 2013

A Year in Pembrokeshire
- Author Jamie Owen
- Photographer David Wilson
- Size 200 x 200mm
- Hardback, 192 pages
- ISBN 9781912213658
- £20
- Publication June 2018

Next page: **Moonlight on the Cleddau Estuary at Port Lion.**

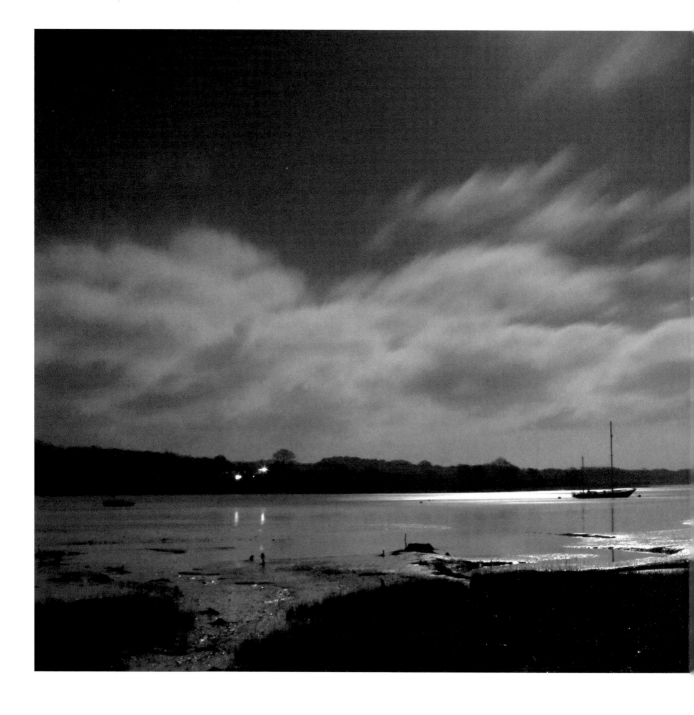